IMAGES
of America
LEAVENWORTH

ON THE COVER: Pictured is Delaware Street looking east from Fifth Street around the 1890s. (Author's collection.)

Kenneth M. LaMaster

Copyright © 2017 by Kenneth M. LaMaster
ISBN 978-1-4671-2679-3

Published by Arcadia Publishing
Charleston, South Carolina

Printed in the United States of America

Library of Congress Control Number: 2017950893

For all general information, please contact Arcadia Publishing:
Telephone 843-853-2070
Fax 843-853-0044
E-mail sales@arcadiapublishing.com
For customer service and orders:
Toll-Free 1-888-313-2665

Visit us on the Internet at www.arcadiapublishing.com

Dedicated to the memory of Carroll Sue Stevenson.

Contents

Acknowledgments		6
Introduction		7
1.	The Beginning	9
2.	Queen City of the West	19
3.	Metropolis	29
4.	In God We Trust	39
5.	School Days	49
6.	Western Branch National Home for Disabled Volunteer Soldiers	67
7.	Hometown Heroes	81
8.	Our Home Sweet Home	97
9.	Yesterday, Today, Tomorrow	109

ACKNOWLEDGMENTS

I would like to thank all those who have made this project possible, first and foremost Zach Baker and the staff of the Leavenworth Public Library. I am truly grateful for you all putting up with me and my questions and your dedication, service, and devotion to the people of Leavenworth. Thanks to Kathy Lafferty and her amazing staff at the Kenneth Spencer Research Library at the University of Kansas; you are absolutely amazing people. To chief of police Pat Kitchens, fire chief Gary Birch, and all the law enforcement officers, firefighters, first responders, and support staff, a simple thank-you just doesn't say how much I truly appreciate each and every one of you and the jobs you do. Thanks to Amy Sloan and her staff at the Leavenworth Public Schools, with special recognition to Carol Dark-Ayers for the amazing job of preserving the school system history; Joseph L. Burks, public affairs officer at the Veterans Administration Eastern Kansas Health Care System; and Mark Cohen of Texas Christian University. Thanks to all the photographers, E.E. Henry, Harrison Putney, Frank Morrow, P.H. Bauer, Richard and Horace Stevenson, and others whose talents behind the lens allow us a look into the past, and to Mary Ellen Everhard for preserving those works. Kathy Seber, Joan Hall, Maggie Linton, and Randy Sparks, thank you for sharing your photographs and your stories. To all those who have contributed photographs and stories, I hope I did you proud. I am forever humbled and grateful to all of you.

Introduction

Telling the story of one of the most historical towns in America is one of the hardest tasks one could ever undertake. Where to start to tell this story? Kansas after all takes its name from the Kanza tribe of Native Americans who inhabited the land when it first appeared on Fr. Pierre Marquette's map of 1673. The first exploration of the territory was made in 1724 by French explorer Etienne Veniard Sieur de Bourgmont, and the first settlement, Fort de Cavanial, was established as a trading post and operated between 1744 and 1764 in the vicinity of Fort Leavenworth. A year after the United States acquired the territory as part of the Louisiana Purchase, the Lewis and Clark Expedition landed in the area on June 2, 1804. Their field notes record their impressions of the site:

> We camped on the south side opposite the first old village of the Kanza which was situated in a valley between two points of high land on the river, back of their village commenced an extensive prairie, a large island in front of which appears to have made on that side and thrown into the current river against the place where the village formerly stood and washes away the bank part. The French formerly had a fort at this place to protect the trade of this nation. The situation appears to be a very eligible one for a town. The valley is very rich and extensive with a small brook meandering through it and one part of the bank affording yet a good landing for boats.

The establishment of Fort Leavenworth on May 8, 1827, marked the first settlement in the territory. The fort initially served as a quartermaster depot, arsenal, and troop depot dedicated to protecting the fur trade and safeguarding commerce along the Santa Fe Trail. Subsequent treaties signed by the US government and the Native Americans in 1829 and 1843 developed what would become the Delaware Trust Lands. The passing of the Kansas-Nebraska Act in April 1854 and a treaty signed on May 6 that same year established what would become the city of Leavenworth, Kansas.

Before the ink was dry on the first document and pen was set to the latter, Missouri senator David Rice Atchison advised those waiting just across the river in the town of Weston, "take the land it is yours," creating a massive influx of squatters claiming and occupying said land. The struggle for what would become known as "Bleeding Kansas" had begun. Even though history tells us the first volleys of the Civil War fell upon Fort Sumter on that fateful day in April 1861, it was in Leavenworth that the first arguments, gunshots, and bloodshed occurred. The anti-slavery

"Free-Staters" and the pro-slavery "Border Ruffians" fought over the belief that all men are created equal and that the states' and their people's rights to self-government should prevail.

As each subsequent decade passed and more people migrated west, Leavenworth rose out of the once vast fertile valley to become the "Queen City of the West." Along those decades, Leavenworth became the first city of Kansas: the first city to develop industry, trade, modern schools, houses of worship, and a pioneering spirit second to none. By the end of its first century, there was no other town bigger or more industrialized from St. Louis to San Francisco. The city knew no stranger, and many prominent figures—military elite, tradesmen, entrepreneurial giants, politicians, future and sitting presidents, one assassin, and a multitude of celebrities—made their way through or put down roots. Its industries would provide goods and services outfitting wagon trains and explorers of the West, for this is where the West began.

For the past 163 years, the vast and amazing history of this town has stood the test of time. The spirit of those of the past still resonates today and lives on in its amazing architecture, historical homes, and those who call Leavenworth home.

As the author, I present to you the reader the stories told by the many historians before me of those who so many years ago endured and sacrificed so much. I pay tribute to the pioneering photographers both polished and novice who through their lenses preserved the past for all the future to view and remember.

One
THE BEGINNING

In April 1854, Pres. Franklin Pierce (pictured) signed into law the hotly contested Kansas-Nebraska Act. In January, Democratic senator Stephen A. Douglas had introduced the Nebraska Bill as a means to organize the area, bringing it under civil control and clearing a path for the development of a transcontinental railroad system that would benefit Douglas's Illinois constituents. Infuriated pro-slavery Southern senators argued that the majority of the territory lay above the boundary established in the Missouri Compromise of 1820, thus making the territory a Free State. To appease the Southerners, Douglas reintroduced the bill as the Kansas-Nebraska Act and repealed the Missouri Compromise. The question of whether the territories would become Free States would be left to the settlers of those territories, thus establishing the rule of popular sovereignty. (Courtesy Library of Congress.)

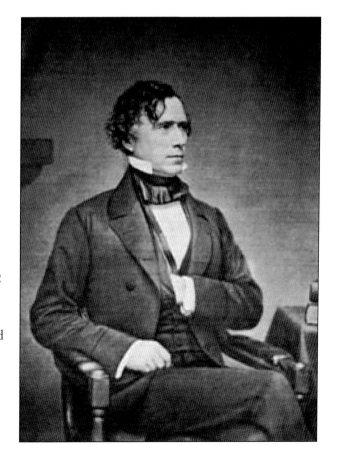

In May 1854, a treaty was signed by the Delaware tribe ceding all its land in the area of what would become Leavenworth. Missouri senator David Rice Atchison, knowing the value of the land, advised many of those living in nearby Platte County and Weston, Missouri, to "take the land it's yours." By June, very little of what would become Leavenworth had not been squatted upon. (Courtesy Library of Congress.)

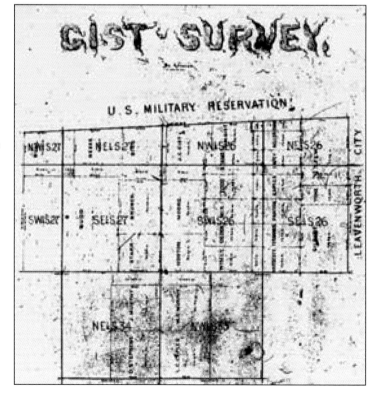

The first land staked in the new territory was that of Gen. George W. Gist, his son John, and Samuel Fernandis. The original Gist Survey platted the 322 acres of the city bordered on the north by the military reservation, the south by Three Mile Creek, and the east by the Missouri River, extending west to the present Twentieth Street area. All of the north-south streets laid out by the survey were numbered, and the east-west streets were named honoring the Native American tribes who originally inhabited the area. (Courtesy Jeff Culbertson, Leavenworth County GIS Office.)

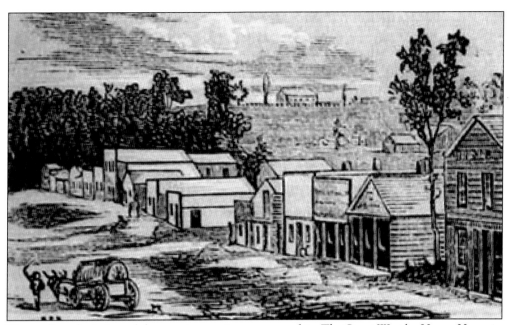

The earliest depiction of the growing territory appeared in The Great West by Henry Howe in 1857. Some of the first buildings housed the Murphy & Scruggs sawmill, the Herald newspaper, the Leavenworth House Hotel, and a warehouse owned by Lewis N. Rees. Howe described the territory as "exceedingly beautiful, with expansive prairies stretching as far as the eye can see." (Author's collection.)

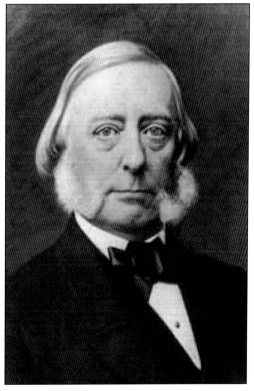

Andrew Reeder, a Democrat from Pennsylvania, was appointed the first territorial governor by President Pierce. Reeder was a strong supporter of popular sovereignty and a proponent of the Kansas-Nebraska Act. He took the oath of office on July 7, 1854, but did not arrive in Kansas until October 7. Accompanied by the newly appointed attorney general of the territory, A.J. Isaacks, Reeder reported to the first territorial headquarters at Fort Leavenworth while Isaacks traveled to nearby Weston, Missouri. Both men met with large crowds, Reeder a Free State crowd and Isaacks a pro-slavery crowd. Reeder was met with optimism, Isaacks with contempt. (Author's collection.)

Samuel D. Lecompte arrived in October 1854 after his appointment by President Pierce as the chief justice of the Kansas Supreme Court. He was a Democrat viewed by many as a pro-slavery advocate. To round out the territorial court were the Hon. Saunders W. Johnson and the Hon. Rush Elmore. (Author's collection.)

As fighting escalated between Free State supporters and the Border Ruffians, the violence became widely reported. Daily letters arrived at the offices of Governor Reeder, senators, and congressmen, as well as newspapers and other periodicals, telling of the horrors committed and demanding relief. Returning to Missouri, David Rice Atchison formed his own brand of law enforcement and commenced to raid, harass, and arrest the Free Staters. Soon, these letters, stories, and even political cartoons dominated the printed press. During this period, *New York Tribune* editor Horace Greeley (pictured) published an editorial coining the phrase "Bleeding Kansas." (Courtesy Library of Congress.)

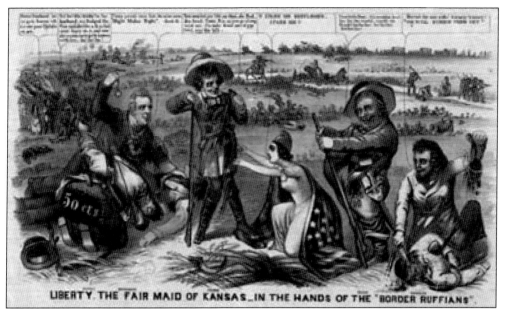

In an attempt to sway public opinion, political cartoons became commonplace. This one was used during the presidential elections of 1856. Standing at center is Pres. Franklin Pierce dressed as a Border Ruffian from Missouri with Lady Liberty on her knees at his feet begging for mercy. On the right are Democratic candidates Lewis Cass and Stephen Douglas, while on the left are Secretary of State William March and candidate (and eventual winner) James Buchanan. (Courtesy Library of Congress.)

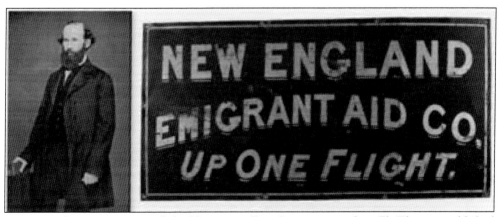

To ensure that Kansas entered the Union as a Free State, men such as Eli Thayer established organizations like the New England Emigrant Aid Company to relocate anti-slavery settlers, often providing hotel accommodations, paying transportation costs, and helping them establish businesses in the territory once they were settled. (Courtesy Library of Congress.)

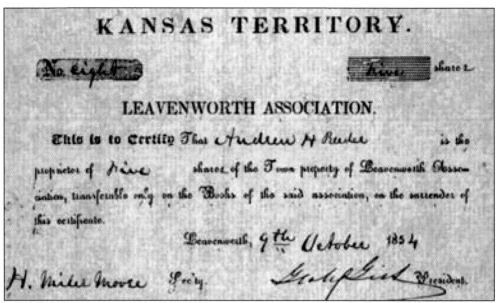

On October 9 and 10, 1854, the first public sale of lots was conducted in Leavenworth. Lots were 24 feet wide and 125 feet deep, with a few 24 feet wide and 116 feet deep. Lots were separated at the rear by alleyways 14 feet wide. Prices ranged from $50 for a residential lot to $350 for a commercial lot. This bill of sale to territorial governor Andrew H. Reeder is signed by George W. Gist, the original surveyor and president of the town association, and H. Miles Moore, the town association secretary. (Author's collection.)

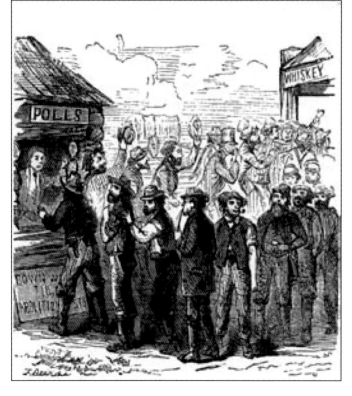

On November 28, large numbers of pro-slavery supporters crossed into Leavenworth by ferry and camped along Three Mile Creek. The next day, the polls opened at the Leavenworth House. Gen. John W. Whitfield was the pro-slavery candidate for a nonvoting seat in Congress, and Judge Robert P. Flenneken was the Free State candidate. The majority of the Free State voters boycotted the elections, believing neither candidate would have enough voice in Washington, DC, to resolve the question of slavery. (Author's collection.)

In the spring of 1855, the town of Bald Eagle was renamed Lecompton, honoring Samuel D. Lecompte, and became the territorial capital of Kansas. In September 1857, a meeting comprising mostly pro-slavery advocates was held at Lecompton to draft a rival to the Topeka constitution of James Lane and the Free State advocates. The Lecompton constitution included the wording "Constitution with slavery vs Constitution without slavery" and allowed those who already held slaves in the territory to keep them while outlawing the introduction of new slaves. Many Free State believers saw this provision as unenforceable and thus rejected the Lecompton constitution three times (December 12, 1857, and January 4 and August 2, 1858). Massive voter fraud occurred during the first two votes. (Author's collection.)

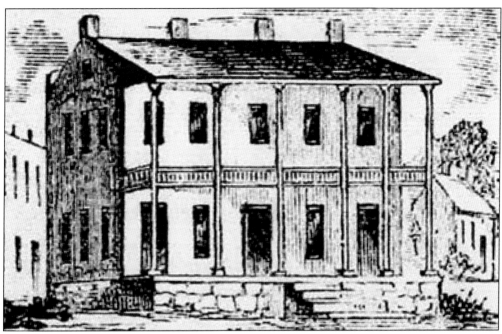

At the center of the voter fraud investigation was John C. Calhoun, who directed his clerk to hide fraudulent ballots from Free State investigators as he headed for Washington, DC, to present the results and argue for acceptance of the pro-slavery Lecompton constitution. The investigation found that nearly 6,000 fraudulent votes had been cast. The results of the investigation ended the majority rule of pro-slavery advocates in the territory. (Author's collection.)

Thomas W. Ewing Jr. led the investigation. Ewing had come to the territory in January 1856 as a strong advocate for the development of the transcontinental railroad system and was considered a moderate on the issue of slavery. Upon his arrival, Ewing opened a law firm and land office along with his elder brother, Hugh, and brothers-in-law Daniel McCook and William T. Sherman. He became a staunch Free State advocate, serving on the constitutional convention and helping Kansas obtain statehood by 1861. Ewing also won election to serve as the first chief justice of the new state of Kansas. (Courtesy Library of Congress.)

Henry J. Adams settled in Leavenworth in March 1855 and became active in the Free State caucuses. In the winter of 1855, Adams was elected to the Free State legislature. Shortly afterwards, Adams and other members of the Leavenworth party were taken prisoner by a group of ruffians known as the Kickapoo Rangers. By the spring of 1857, Adams was elected as the first Free State mayor of Leavenworth, serving two terms. (Author's collection.)

Free Staters held a convention in Leavenworth in January 1858 and drew up the framework of what would become the Leavenworth constitution. The document included a bill of rights that declared "All men are by nature equally free and independent, and have certain inalienable rights, among which are those of enjoying and defending life and liberty, acquiring, possessing, and protecting property, and seeking and obtaining happiness and safety; and the right of all men to the control of their persons exists prior to the law, and is inalienable." It also called for the permanent banning of slavery in the state and petitioned the basic rights of women. The constitution was provided for by an act of the territorial government in February 1858. It was adopted by the convention at Leavenworth on March 3, 1858, and passed by a public vote on May 18, 1858. The US Senate did not approve of the laws written into the document and considered it too progressive. One of the convention members who helped in the development of the constitution was John Richey (pictured). The *Leavenworth Times*, in an article dated July 17, 1859, described Richey as an ultra-abolitionist friend of John Brown who had helped fugitive slaves to freedom through the Underground Railroad. He was an advocate of women's rights, a teetotaler, and a general advocate for reform. (Author's collection.)

Marcus J. Parrott was born in Hamburg, South Carolina, studied law at Cambridge University, and was admitted to the bar in Dayton, Ohio. He served as a Democratic member of the Ohio House of Representatives. In 1855, Parrott moved to Leavenworth, where he changed his affiliation to the Free State Party. He also served as a court reporter for the first session of the Kansas Supreme Court. Parrott was elected as a Leavenworth delegate to the Topeka Constitutional Convention, which convened for the first time on October 23, 1855. In July 1857, he was elected the delegate to Congress under the Topeka constitution, and he served for four years. Parrott was present on January 29, 1861, when Congress ratified Kansas as the 34th state. Shortly afterwards, he transmitted to his hometown of Leavenworth the news that all Kansans wanted to hear. (Courtesy Library of Congress.)

Two

QUEEN CITY OF THE WEST

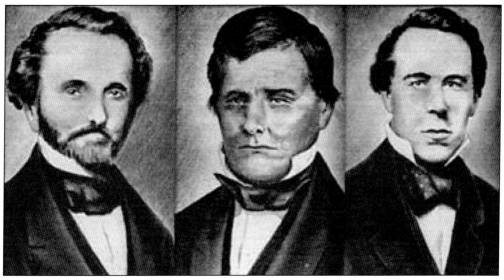

As the territory fought for statehood, Leavenworth continued to grow not only in population but also in commerce. The new gateway to the West opened the door for many looking to stake their claim in life. Among the first to realize the untapped potential of free trade in the new territory and beyond were, from left to right, William Russell, William Waddell, and Alexander Majors. Prior to 1854, government freight contracts were awarded to companies for relatively small shipments. At the time, Majors owned a small freight company, while Russell and Waddell operated a wholesale trading company. The men realized that their individual companies were too small to handle large government contracts, so in December 1854, the three combined their companies into one. They also moved their operation from the small town of Lexington, Missouri, to the much larger and more profitable city of Leavenworth. The size of their company was instrumental in landing numerous large government contracts. Initially, Russell, Majors & Waddell lost as much as $500,000 in a single year due to loss of oxen, wagons, and supplies, but the experience gained allowed the company to rebound to an annual profit of $300,000. (Author's collection.)

In 1854, the enterprising John F. Richards (right) went to work for a wholesale hardware company in St. Louis. Making $25 a month, he saved as much as possible. He earned the trust of his employer and set sail for Leavenworth with a little money and a large stock of hardware that had to be shipped on a separate boat. Richards opened the first hardware store in the territory in March 1857 at the corner of Second and Cherokee Streets. To keep overhead to a minimum, he slept under the counter of his new store. After establishing and expanding the business, he moved into a three-story brick building at Delaware and Third Streets. In 1862, Richards merged with W.E. Chamberlain, who moved his stock from Kansas City to form the Richards and Chamberlain Hardware Company. In 1866, Richards bought out Chamberlain and hired John Conover (left) as the company's first traveling salesman. The store was sold to the Park-Crancer Company in 1884. (Author's collection.)

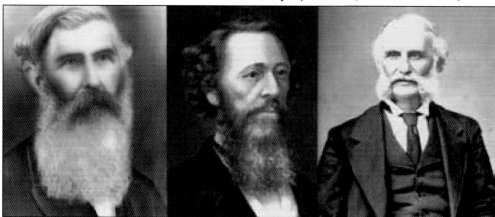

The first newspaper venture in the territory was editor Gen. Lucien J. Eastin's *Kansas Herald*, followed by the *Territorial Register and National Democrat*, owned and edited by Mark W. Delahay. Described as a Free State paper with conservative views, it was seized after only a few months in operation and its presses tossed into the Missouri River. Other papers followed: the *Journal, Young American, Daily Ledger* (edited by Robert Cozier), the *Kansas Zeitung, Frie Presse*, and many more. From left to right are Eastin, Delahay, and Cozier. (Author's collection.)

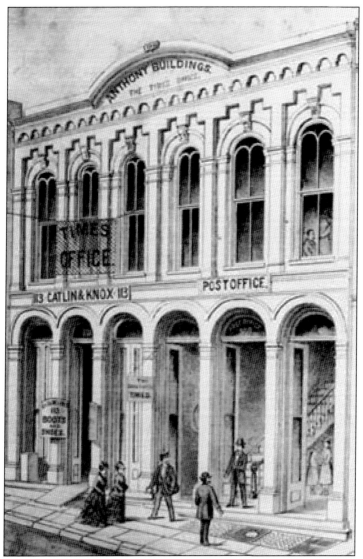

In 1854, Daniel Reed Anthony migrated to the territory by way of the New England Emigrant Aid Company. Upon his arrival, he began assisting William Dominick Mathews in aiding fugitive slaves along the Underground Railroad. In January 1861, Leavenworth was the end of the telegraph system, and upon receiving the news that Kansas had been admitted into statehood, Anthony mounted a horse and rode to Lawrence to make the announcement public. Also in 1861, he purchased the *Leavenworth Daily Conservative*. Later that year, rival editor Robert C. Satterley accused Anthony of cowardice. A gun battle ensued, resulting in Satterley's death. Anthony was acquitted of all charges. During the next several years, he continued to purchase rival local newspapers until he had a monopoly. During the Civil War, Anthony enlisted several volunteers to aid in the burning of buildings belonging to Confederate sympathizers and was arrested for interfering with martial law. In 1871, he began publishing the *Leavenworth Times*. In 1875, he was shot and severely wounded by rival editor William Embry. During his lifetime, Anthony would serve as postmaster, mayor, and city council member. The *Leavenworth Times* remained under Anthony family control until 1960 and is currently the longest-running daily newspaper in Kansas history. (Author's collection.)

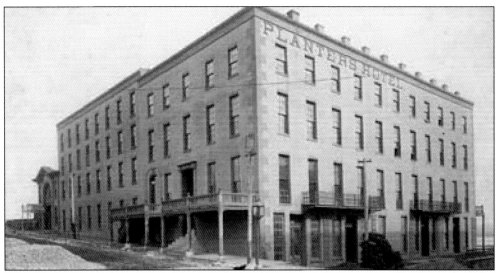

In December 1856, the Planters Hotel opened at the corner of Shawnee and Main Streets (the current Esplanade Street). Previously, the town's hotels consisted of the Leavenworth House and numerous boardinghouses throughout the city. The Planters Hotel contained 100 rooms, a dining room, a barbershop, and a bar. Considered a pro-slavery hotel, it was the scene of many politically charged debates and brawls. On December 5, 1859, presidential candidate Abraham Lincoln spoke from the steps of the hotel, urging voters "not to use force but to use the vote at the ballot box to keep slavery from expanding into the territory. (Author's collection.)

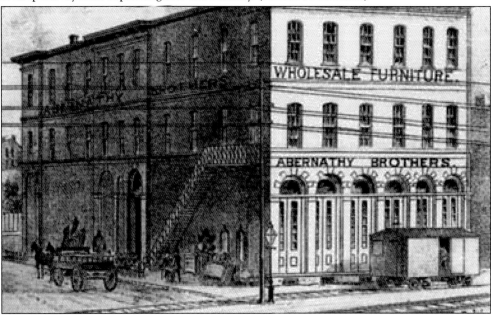

In 1856, brothers James, William, and John Abernathy chose Leavenworth as the base of operations of the Abernathy Bros. Wholesale and Retail Company. Their manufacturing of furniture began at the corner of Seneca and Second Streets, with a warehouse on the corner of Main and Choctaw Streets. Their retail, wholesale, furniture, and carpeting store was in a three-story building at 306 and 308 Delaware Street. The company continued to operate into the 1940s in Leavenworth and 1950s in Kansas City. (Author's collection.)

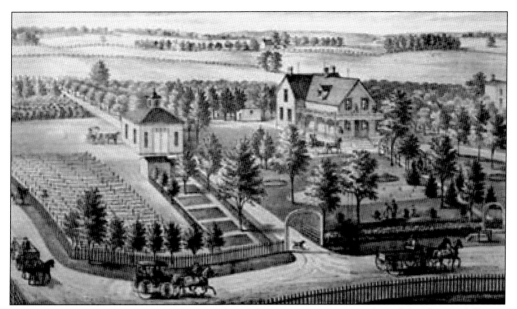

Several horticulturists of the day devoted their life to experimenting with and developing different varieties of fruits and vegetables, like Dr. Joseph Stayman, whose orchards and vineyards were on the corner of Maple Avenue and Santa Fe Street. Many different varieties of apples, grapes, strawberries, and raspberries were developed and shipped worldwide. At one point, Dr. Stayman's experiments grafting fruit trees led to one single tree producing 16 different varieties of apples. Dr. Stayman and William Tanner organized the Kansas State Horticultural Society in 1866. (Author's collection.)

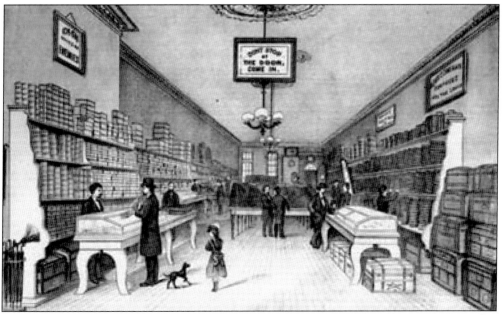

John Seckler established his clothing business in 1863 at 317 Delaware Street, promising his goods were marked in plain figures and sold at bottom prices. His company advertising included the phrases "cash makes no enemies," "we can suit all," and "come again our prices always the lowest." (Author's collection.)

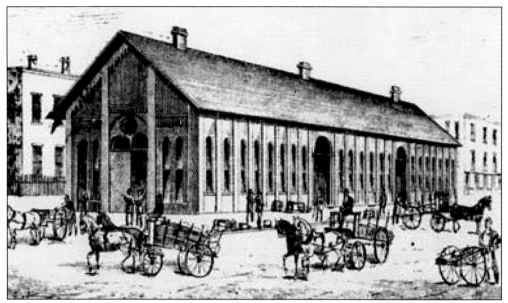

Constructed in 1867 for $75,000, the Market Building became one of the busiest buildings in town. Facing Cherokee Street, the 65-by-285-foot, two-story building was bordered on the west by Seventh Street, the east by Sixth Street, and the south by Choctaw Street. Early on, local farmers would bring wagonloads of fruits, vegetables, hay, corn, and cordwood to sell. Early city directories list the building as Central Market Square, and later directories show this building was owned by B.C. Clark, who operated a stone and glassware business. This building sat on the current site of Haymarket Square. (Author's collection.)

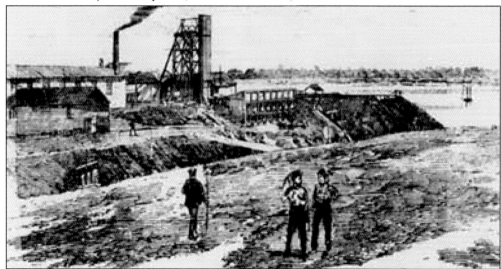

Coal mining in the area was first conducted by the military reservation of Fort Leavenworth. Coal was mined in the Salt Creek valley to keep the blacksmith and wagon repair shops operational. In October 1869, coal was discovered below the city at a depth of 700 to 800 feet. The building currently occupied by Geiger Ready Mix on South Second Street was originally the offices of the Home Coal Company. Coal companies in the area included Riverside Mining, Carr Coal, and Brighton Mine. This etching depicts the first coal mine at the river's edge in the northeast portion of the city, owned by Riverside Mining. (Author's collection.)

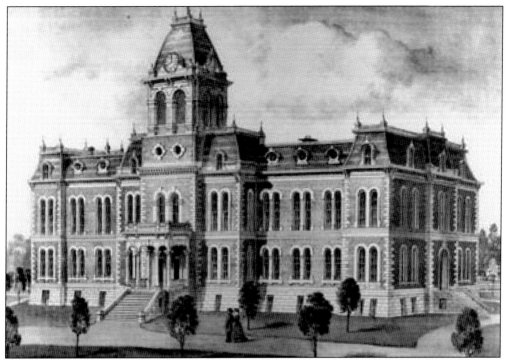

On May 20, 1872, construction began on the original Leavenworth County Courthouse on land donated to the city by Jeremiah Clark in 1858. On February 17, 1874, the city took possession of the completed $100,000 structure. Newspapers immediately began touting the courthouse as the best ever built in the West. A fireworks display on the courthouse grounds celebrating the 10th anniversary of the end of the Civil War caused a fire in the cupola. The fire was quickly extinguished by local firefighters and several other men. A second fire on March 22, 1911, rendered the courthouse a total loss. (Author's collection.)

Following the close of the Civil War and into the mid-1870s, the banking business was central to the development of the city. Early banks found difficulty establishing roots due to the uncertainty and the violence of the young territory. Beginning in 1866, major banks began to emerge, such as the First National Bank, established by Lyman Baker Sr. and his sons Lyman Jr. and Lucien. Other banks to follow included the Second National, Manufactures National, Union Savings Bank, and the Wulfenkuhler Bank. These banks averaged daily deposits greater than $160,000, with an average capital exceeding $1 million. (Author's collection.)

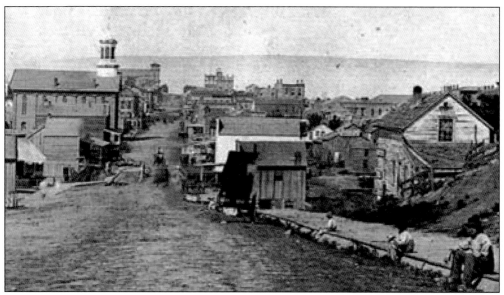

By the mid-1860s, photography was one of the fastest growing industries in the city. In the past, artists such as George Catlin and Frederic Remington had documented the movements of military personnel from Fort Leavenworth into the West. Now men such as E.E. Henry and Alexander Gardner, the famed photographer of the Civil War and the conspirators in Lincoln's assassination, recorded the progress through their lens for all the world to see. This early photograph of Fifth Street looking north from Three Mile Creek shows the Congregational church at the corner of Fifth and Delaware Streets with the Immaculate Conception Cathedral and the Morris School on the horizon. (Courtesy Library of Congress.)

Ebenezer Elijah Henry operated his first photography business in Port Hope, Ontario, about 1857. His last known business advertisement in Port Hope appeared in 1864. He relocated to Leavenworth between 1864 and 1865 and appears for the first time as a resident of the city on the June 6, 1870, census. He operated a shop on Delaware Street capturing images of dignitaries, military officers, and locals. (Author's collection.)

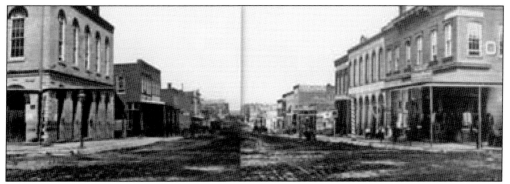

This early Henry photograph shows Shawnee Street looking east from Fifth Street. In the foreground on the left is the first Leavenworth City Hall. Also in the foreground are the Star of the West Saloon, Delmonico Restaurant, and other businesses of the day. (Courtesy Library of Congress.)

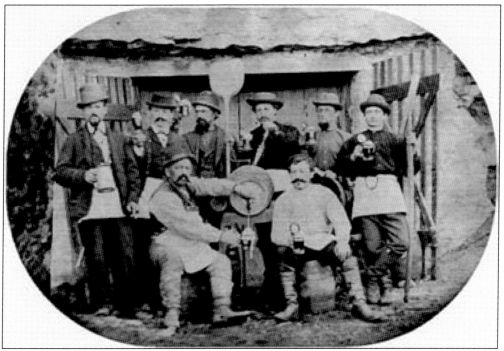

Another industry taking root in the city was brewing. This 1874 photograph shows the entrance to the storage caves of Joseph Kunz. Kunz resided in a large stone house on the south bank of Three Mile Creek where he also brewed his beer. Once the beer was cooled, his five employees moved the barrels to the underground storage, described by Kunz as "sandstone vaults connected by tunnels with the purest of water flowing through them." The first brewery in town began operation in 1854 as the Leavenworth Brewing Company, owned and operated by John Grund. The last of the breweries before Prohibition was Brandon and Kirkmeyer, which operated the largest and most modern facility with vats that could produce 650 barrels of beer at a time and had annual profits exceeding $100,000. (Courtesy Leavenworth Public Library.)

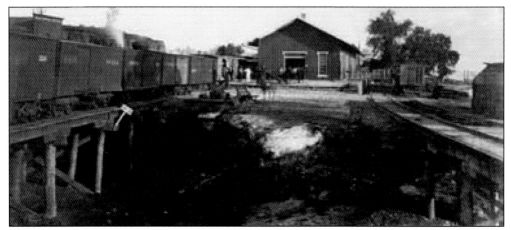

This photograph of a train depot is credited to Alexander Gardner. In the background at left is a sign for the National Hotel, and the Morris School is barely visible in the background. City directories place this building around the 500 block of South Second Street. (Courtesy Getty Images.)

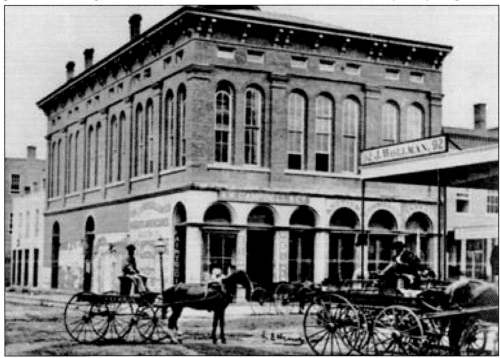

The original Stockton Hall was built in 1857 on the southwest corner of Fourth and Delaware Streets. It was named for J.B. Stockton, described as a spirited citizen and hustler. The wooden building housed storerooms on the first floor and a meeting room and theater on the second floor. In the summer of 1858, a meeting here resulted in the organization of the territory's Democratic Party. On December 3, 1859, Abraham Lincoln delivered a speech on popular sovereignty to a capacity audience. In December 1863, John Wilkes Booth performed on the same stage from which Lincoln had spoken. On January 25, 1864, Stockton Hall was destroyed by fire. A new all-brick Stockton Hall opened on September 10, 1864, featuring *The Hunchback* by Sheridan Knowles. The building continued as a meeting hall and theater until 1940, when it became the home of the First National Bank. (Courtesy Leavenworth Public Library.)

Three

METROPOLIS

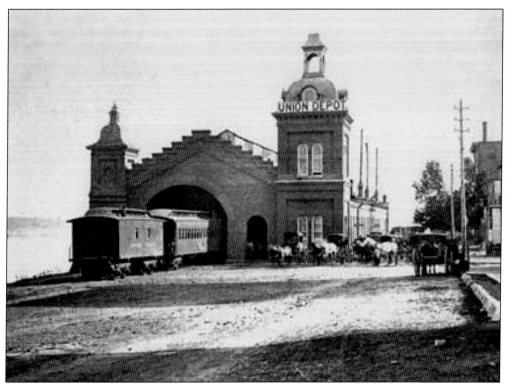

The first territorial legislature chartered five railroad companies in 1855, including the Leavenworth Lecompton and the Leavenworth, Pawnee & Western. The first line to cross Leavenworth was the Missouri River Railroad, running from Wyandotte north through Leavenworth and joining the Missouri Pacific to the Nebraska border. The Leavenworth City Railroad company began in 1860, offering services from nearby Fort Leavenworth into downtown Leavenworth. By 1880, eight railroads served the area providing passenger and freight services. Four local depots provided upwards of 75 scheduled passenger arrivals daily. Pictured is the first Union Depot in Leavenworth, on South Main and Walnut Streets just south of Three Mile Creek. Through the years, the major railroads attempted to connect with Leavenworth, but most never developed beyond the bond issue stages. (Author's collection.)

This mid-1860s view overlooks Leavenworth from atop Government Hill looking east. The area in the foreground would become the location of the US Penitentiary in 1895. This photograph was included in the Alexander Gardner series of stereo views titled *Across the Continent on the Kansas Pacific Railroad*. (Author's collection.)

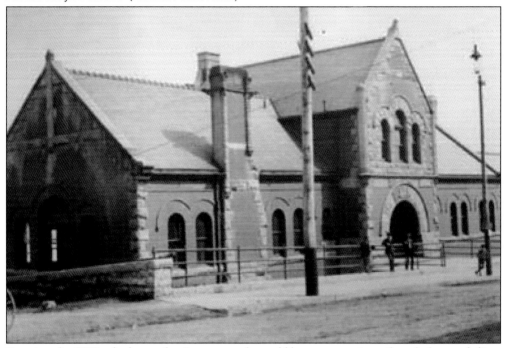
Entering the 1880s, the hopes that Leavenworth would become a major railway hub were fading. The final attempt to make the town a major railway center failed in 1871 when investors tried to construct the Central Kansas Railroad. The narrow-gauge railroad was to run from Leavenworth to the western border of the state. By then, all the regular railroad companies were using standard-gauge equipment, thus rendering the Central Kansas obsolete. Pictured is the second Union Depot, facing Delaware Street on Main Street. Local architect and builder James McGonigle designed and built this depot, which opened in 1888. (Author's collection.)

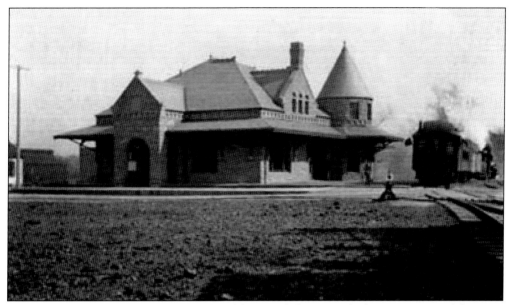

The Atchison, Topeka & Santa Fe Railroad (AT&SF) depot was built in 1887 west of the main downtown business district, just off Broadway on Shawnee Street, and operated as a passenger and freight depot. In addition to serving passengers of the AT&SF, the depot also served passengers from Fort Leavenworth on the interurban streetcar until 1930. Operations as a freight depot ceased in 1982; the building was purchased by a private investor and is currently a restaurant. It was listed in the National Register of Historic Places in 1986. (Author's collection.)

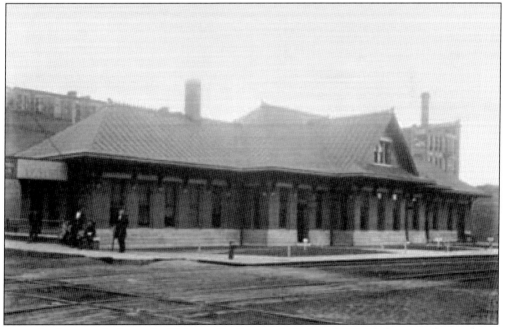

An early photograph shows the Chicago, Burlington & Quincy (CB&Q) depot on the northeast corner of Fifth and Choctaw Streets. In 1901, the CB&Q began operations from Leavenworth to Billings, Montana. The depot was designed and constructed by James McGonigle. (Courtesy Kenneth Spencer Research Library, University of Kansas Libraries.)

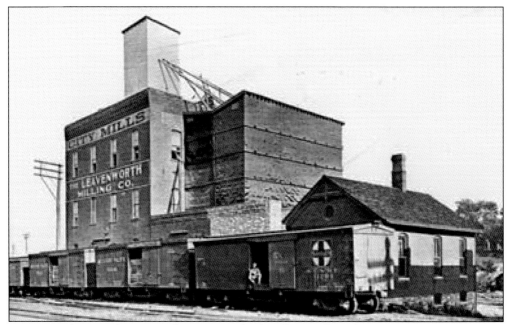

In 1854, Earle Si Bunbing owned Leavenworth's first flour mill on the northwest corner of Main and Short Streets. Over the next 20 years, mills sprang up across the city. Several small ones could not compete with the larger mills in Missouri. The Plummer Mill, on Kickapoo Street, and the Havens Mill, on Main Street at Three Mile Creek, were destroyed by fire. Built in 1883, the White Mill operated successfully and was purchased by local businessman H.D. Rush, who renamed it the Leavenworth Milling Company. On the south side of Choctaw Street near Fifth Street, it would become one of the most successful flour mills in the country. (Author's collection.)

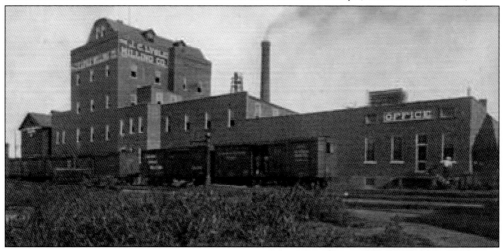

The most successful mill in Leavenworth began as New Era Mills on the north side of Choctaw Street at Sixth Street. It was owned and operated by the Kelly and Lysle Milling Company until J.C. Lysle bought out his partner. It became the largest and best milling operation west of the Mississippi River and introduced Kansas Flour and other products throughout the western United States as well as in Europe. In *The History of Leavenworth, Kansas*, authors Jesse A. Hall and Leroy T. Hand proclaimed, "Our flour mills are among the largest industries of our city and upon their white wings bear our fame to every civilized land." (Author's collection.)

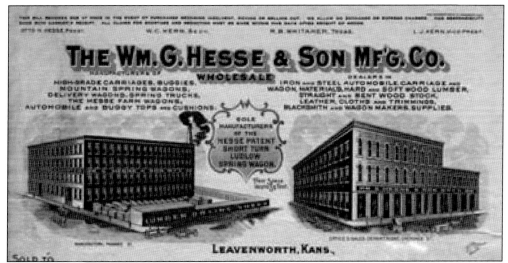

One of the city's first major manufacturers, William G. Hesse and Son, opened its first shop in 1857 on Shawnee Street between Third and Fourth Streets. By 1860, it moved into a much larger building at Metropolitan Avenue and Seventh Street. At first, the company repaired wagons, but through its first decade, wagon manufacturing became its primary focus. After the Seventh Street location was destroyed by fire in 1871, William Hesse relocated to Cherokee Street between Third and Fourth Streets. His son Otto became a full partner in 1892, and in 1909, Otto Hesse's buildings at 408–410 Cherokee Street manufactured, repaired, and painted gasoline and electric automobiles. At the outbreak of World War I, the company manufactured motor ambulances and trailer ambulances. After the war, the company manufactured two-wheel, four-wheel, and semi-trailers. Otto Hesse retired in 1930 and sold the company. (Author's collection.)

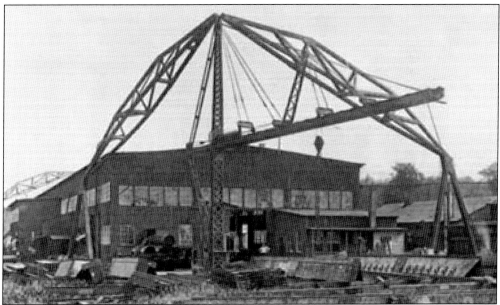

Missouri Valley Bridge & Ironworks began in the mid-1870s and employed 75 men in the manufacture of long-span, draw, lattice, and girder-style bridges. Other products included columns, trestle work, roof trusses, and bridge turntables. The company was between Thornton and Lawrence Avenues on the site of today's Leavenworth City Municipal Service Center. (Author's collection.)

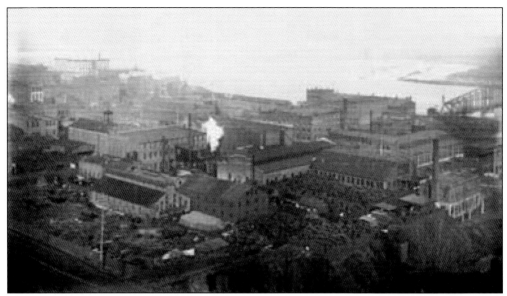

Malson, Willson & Company began manufacturing flour mill machinery, stationary and portable engines, sawmills, pumps, mining machinery, ironwork, waterwheels, and general mill furnishings on the corner of Second and Choctaw Streets in 1858. In 1869, after several changes in partnerships, the name was changed to the Great Western Manufacturing Company. The foreground of this photograph, taken by Frank Morrow from the courthouse tower, contains the vast operation of the company. (Courtesy Kenneth Spencer Research Library, University of Kansas Libraries.)

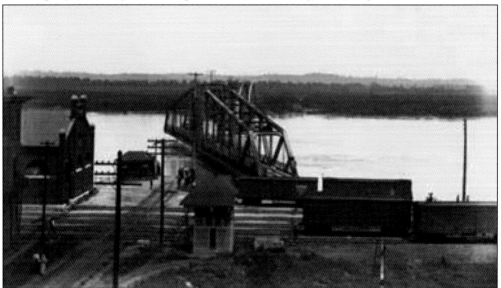

Construction of the $300,000 Leavenworth Terminal Bridge, often referred to as the Leavenworth Bridge, began in 1892, and it was dedicated on January 2, 1894. This 1,100-foot-long swing bridge was constructed under the supervision of George S. Morrison and involved the Missouri Valley Ironworks and Union Bridge Company. The bridge swung open to accommodate barge traffic along the Missouri River. It was abandoned in the 1970s, and a demolition crew using explosives brought the structure down on July 21, 1987. (Courtesy Kenneth Spenser Research Library, University of Kansas Libraries.)

The Carnegie Building created excitement in the city. Construction began in 1900, and the building opened in 1902; it housed the Leavenworth Public Library until 1987. From 1987 to 2012, the building was operated by a nonprofit organization dedicated to teaching visual arts, painting, art history, music, dance, pottery, and drama. In 2016, the building was renovated into a multiuse facility with space for artist's studios, offices, and apartments. (Author's collection.)

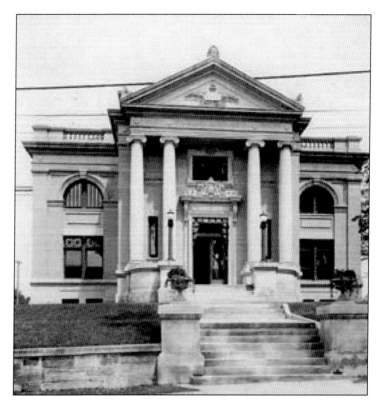

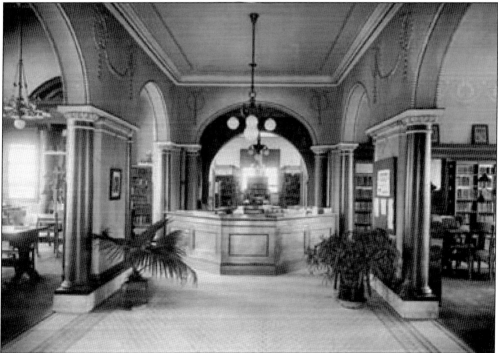

This view from the main entrance of the Leavenworth Public Library at the Carnegie Building facing east shows the adjoining reading rooms and the main librarians' desk. (Author's collection.)

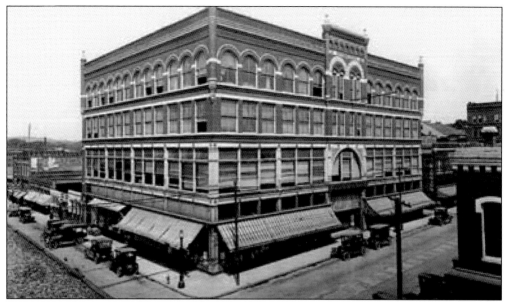

Henry Ettenson arrived in Leavenworth in 1868 and was described by many as the most successful door-to-door salesman ever. Ettenson opened his first store in 1872; the business was such a success he moved into a five-story building on the northwest corner of Fifth and Cherokee Streets in 1873. Less than a year later, that building was destroyed by fire; undeterred, Ettenson rebuilt his business into a four-story department store. In 1888, he partnered with Benjamin B. Woolfe and renamed the business Ettenson and Woolfe. Following Ettenson's passing in 1909, his sons continued the business. In the 1940s, the Ettenson family sold the business to B.R. Phillips, who operated a furniture store. In 1953, the building was sold to Leland "Lee" Winetroub and operated as Lees Furniture. The building was sold to a local businessman in 2013 and in 2017 is undergoing renovation. (Author's collection.)

One of Leavenworth's most respected businessmen was William Small. He came to the city from Hamilton, Ontario, in 1872. By 1875, William Small & Company opened its doors. Specializing in dry goods and millinery products, the company became a respected mercantile business in the city. (Author's collection.)

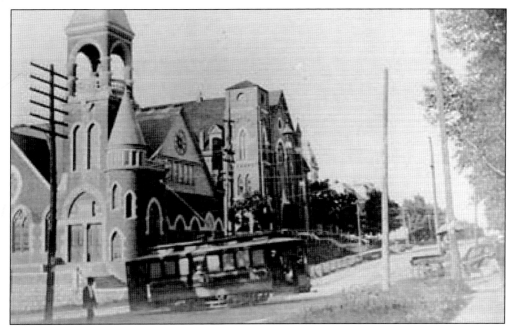

Early public transportation throughout the city began with a mule-drawn streetcar system in the late 1860s. By the late 1880s, Leavenworth's first electric streetcar began operation connecting all major points from Metropolitan Avenue south to the Veterans Hospital, as far west as Sixteenth Street, and east to Main Street. This photograph shows the streetcar traveling south past the First Congregational Church at Fifth and Walnut Streets. (Courtesy Leavenworth Public Library.)

In January 1900, an interurban line connecting Leavenworth to Kansas City was opened. It operated locally on existing track, and new track was laid connecting the 26-mile stretch between the cities. In 1905, the company was sold to the Fisk-Robinson group and renamed the Kansas City Western Railway. Though the line proved popular and profitable, the interest burden upon the company caused it to declare bankruptcy in 1920 and reorganize as the Kansas City, Leavenworth & Western. The company remained profitable throughout the Depression. In 1938, the construction of a dam forced track relocation and caused the line to cease operation. (Author's collection.)

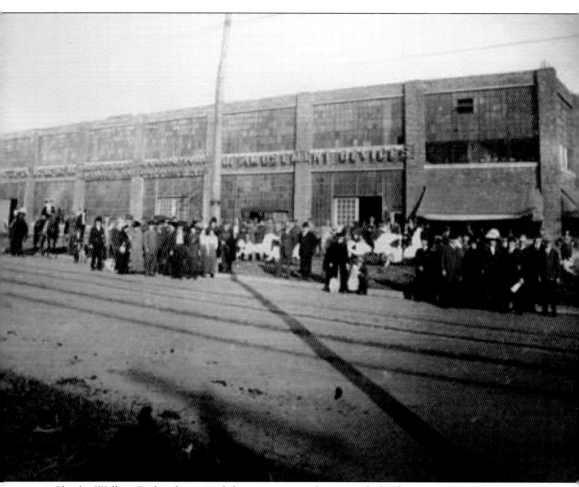

Charles Wallace Parker discovered the excitement of a carousel after he spent 85¢ of the last dollar in his pocket to amuse his daughter. Parker soon after purchased his first portable carousel to go along with a portable shooting gallery he had built a few years earlier. From the very beginning, Parker believed he could build superior carousels, and in 1896, the C.W. Parker Amusement Company began operations in Abilene. By 1910, Parker planned to expand his business, but a dispute with city officials over land caused him to move to Leavenworth. He built a factory on the outskirts of town and began operations in 1911. His operation continued to grow until every square foot of his factory was in use, including the roof and the land surrounding the factory. Over time he purchased additional buildings around town for manufacturing and storage of his amusement park creations. As his business expanded, his rides became more elaborate, and he began to feature other animals as mounts. The company survived material shortages caused by World War I and the Great Depression. Following the death of C.W. Parker in 1932, the company was run by his son until 1955. C.W. Parker's innovation and attention to the industry gained him a reputation as "the Carnival King." His business made Leavenworth the winter quarters for many carnival shows that toured the country and was one of the city's main tourist attractions. (Courtesy Barbara Fahs Charles and the C.W. Parker Carousel Museum.)

Four
IN GOD WE TRUST

On October 8, 1854, Leavenworth was but a few months old when the Rev. W.G. Caples, an elder of the Methodist Episcopal Church, South, in nearby Weston, Missouri, delivered the first religious services in town. Historians H. Miles Moore, Jesse Hall, and Leroy T. Hand place the sermon under a cottonwood tree on the Missouri River in the northeast part of the city. Henry Howe provided this illustration in his book *The Great West*. (Author's collection.)

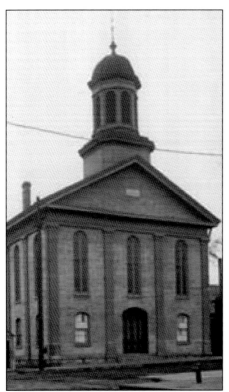

In February 1855, the Leavenworth Mission of the Methodist Episcopal Church began holding services at the Leavenworth Hotel on the corner of Main and Delaware Streets. The Methodist Church, South, was constructed by Amos Rees in 1857 on the north side of Choctaw Street. The cornerstone was laid for the church building on May 30, 1859, at Fifth and Choctaw Streets (pictured), with the first service held in the basement on Sunday, December 4, 1859. The church was completed and dedicated on June 29, 1862. (Courtesy Kenneth Spencer Research Library, University of Kansas Libraries.)

The biggest problem encountered by the church at Fifth and Choctaw Streets was the constant noise and dust from the adjacent railroad. In 1908, the congregation voted to sell the parsonage at Sixth and Walnut Streets and use the funds raised to purchase land at Fifth and Chestnut Streets. On September 15, 1912, the current building was dedicated as the First Methodist Episcopal Church of Leavenworth. In 1968, the name was changed to the First United Methodist Church after the merger of the Methodist and the United Brethren Churches. (Author's collection.)

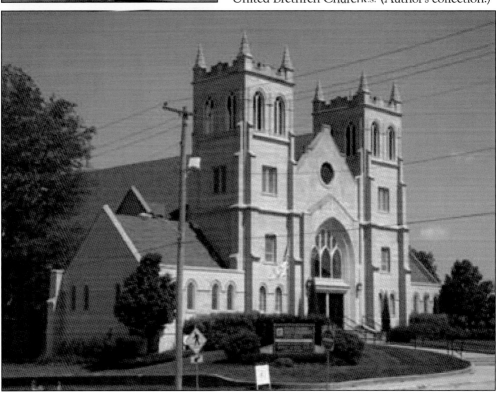

The first Catholic mass in Leavenworth was conducted by Fr. William Fisch in October 1854 in the home of Andrew Quinn on Shawnee Street near Second Street. A bureau was used as an altar. Upon his arrival on August 18, 1855, Bishop John Baptist Miege, vicar apostolic of the Indian Territory, formally established the Parish of the Immaculate Conception. The bishop's first official act was to hold mass, again in the home of Andrew Quinn, with the entire Catholic population of Leavenworth in attendance, a total of nine families. (Courtesy Immaculate Conception–St. Joseph Parish.)

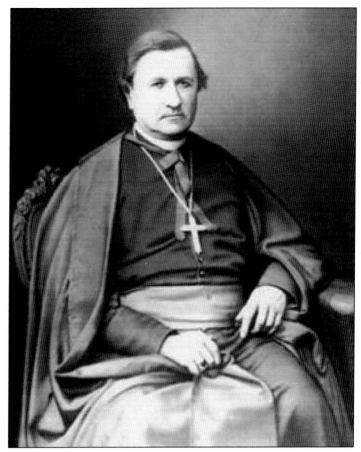

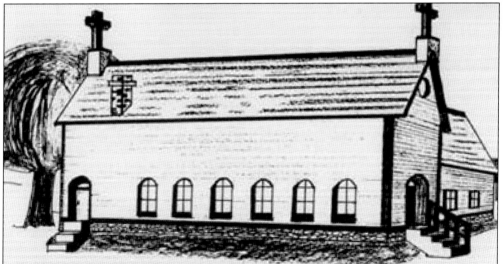

Shortly after his arrival, the bishop began construction of the first Cathedral of the Immaculate Conception. The 15-by-20-foot structure was built on the southwest corner of Kickapoo and Fifth Streets, the highest hill in town. The total cost of the church and adjoining stable was estimated at $11,000. (Courtesy Immaculate Conception–St. Joseph Parish.)

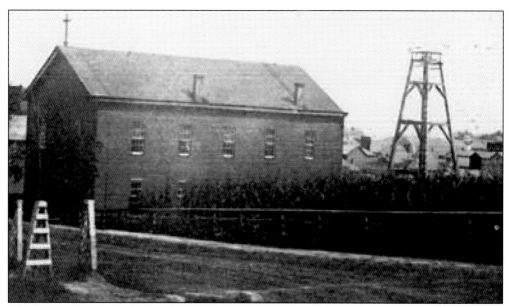

The first St. Joseph Catholic Church was a two-story structure measuring 30 by 60 feet facing Osage Street just east of Broadway. The second floor was used for divine service, while the first floor served as the priest's quarters and schoolrooms. The first priest ordained in Kansas was Fr. Cazmir Seitz. He was also the first priest of St. Joseph Parish. Fr. William Fisch replaced Father Seitz, who had become ill, and was in charge of the church when it was dedicated on July 10, 1859. (Courtesy Immaculate Conception–St. Joseph Parish.)

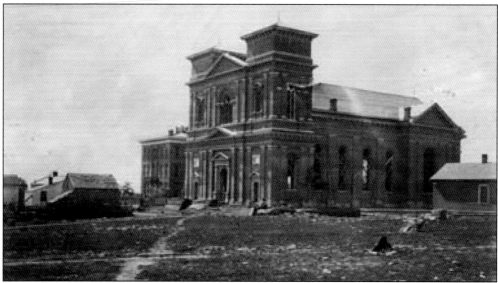

Between 1855 and 1859, the Catholic population of Leavenworth grew from 15 to 2,000. The first cathedral was expanded or rebuilt three times during those years to facilitate the ever-growing parish. The excavation for a new cathedral began in the spring of 1864, with the laying of the cornerstone on Sunday, September 18, 1864. The dedication was held on December 8, 1868. This photograph of the cathedral under construction appeared as part of Alexander Gardner's stereo views series *Across the Continent on the Kansas Pacific Railroad*, released in 1867. (Courtesy Getty Images.)

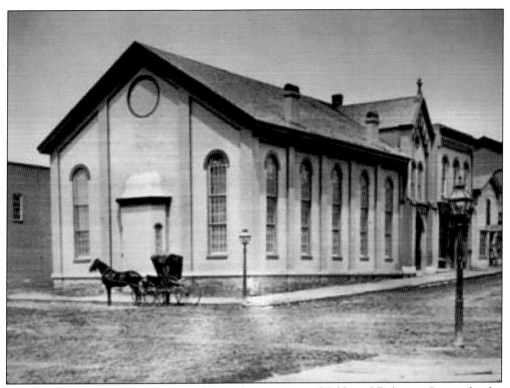

In 1860, two lots were purchased on the northwest corner of Fifth and Delaware Streets for the First Congregational Church. This 42-by-60-foot brick church was built for a total cost of $5,000. In 1863, the town's first pipe organ was installed. In 1867, this church building was sold to the Wulfenkuhler Bank. (Courtesy Leavenworth Public Library.)

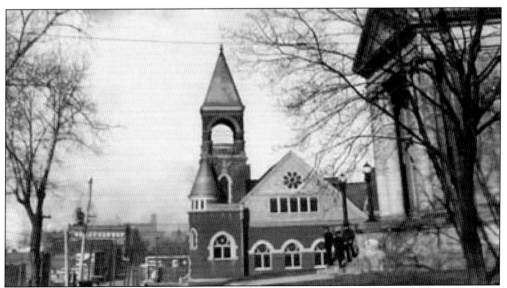

In 1867, a new First Congregational Church was constructed on the corner of Fifth and Walnut Streets. The cost totaled $30,000, and the contents of the original church, including the pipe organ, were relocated here. (Author's collection.)

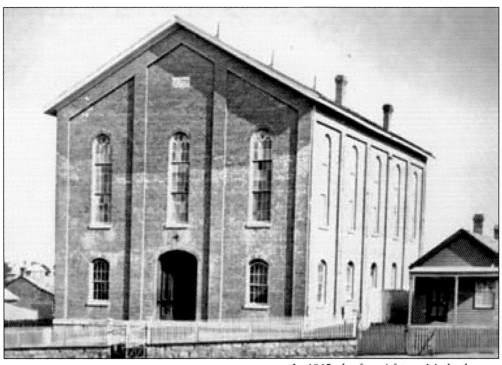

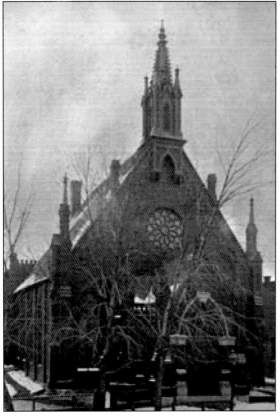

In 1865, the first African Methodist Episcopal church was opened on the corner of Fourth and Kiowa Streets. The edifice was constructed on a high point in the northeastern part of the city as a symbol to all the enslaved that freedom awaited them. In 1985, the 120-year-old church was found to have structural damage. As the faithful congregation sought companies to make repairs, the building collapsed. The spirit of the congregation came through when a new church was opened a few years later on this historical site. (Courtesy Leavenworth Public Library.)

The first Presbyterian services were held by the Rev. H.M. Hobson in the open air in the summer of 1855. By the fall of 1855, the first church building was erected at the corner of Sixth and Miami Streets, with the Rev. A.W. Pitzer officiating. To meet the needs of a growing congregation, a new church was constructed in 1863 on the north side of Delaware Street near Seventh Street. (Courtesy Leavenworth Public Library.)

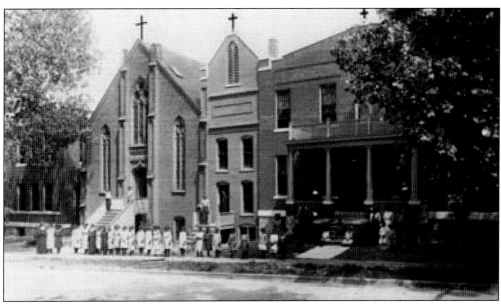

In 1874, the first African American Catholic church west of the Mississippi River was established by Bishop Louis Fink. The Oblate Sisters of Providence, from Baltimore, Maryland, were the first group of African American nuns in the United States and worked in the church, school, and two orphanages, Guardian Angels Home for Boys and the Holy Epiphany Home for Girls. Priests from Immaculate Conception and St. Joseph's served this church as well. Holy Epiphany was closed in 1954. (Courtesy Leavenworth Public Library.)

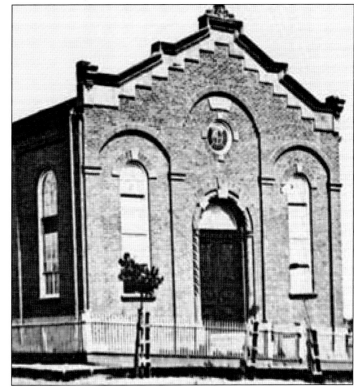

In a March 1, 1925, *Leavenworth Times* article, local businessman Morris Abeles discussed the beginning of the Jewish community in Leavenworth in 1855. Prior to 1864, the Jewish community consisted of both Orthodox and Modified Reform congregations. Services were held whenever possible in rented halls throughout the city. The first synagogue was established in 1866 at the corner of Sixth and Osage Streets. This building served the Jewish community until the new B'nai Jeshurun opened at the same address in 1918. (Author's collection.)

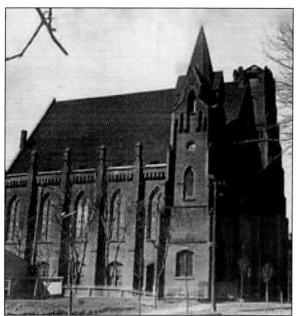

The town's first Baptist congregation, Tabernacle, was organized in 1858 by Reverend Kermot, followed by First Baptist under Reverend Barrett in 1860. They united in 1864 as First Baptist Church under Rev. Winfield Scott. Reverend Scott's early services were conducted in the First Presbyterian Church building and Laing's Hall. The cornerstone of this building was laid on November 2, 1865, and the church's dedication service was held on February 22, 1871. The interior was remodeled after a fire on March 27, 1912, and the church continued operation until 1956, when the congregation moved into a new facility at Thirteenth and Osage Streets. (Courtesy Leavenworth Public Library.)

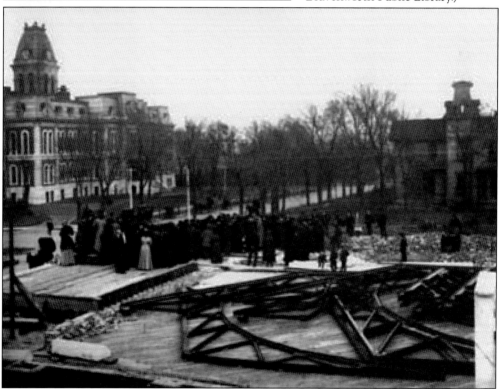

On Sunday, January 3, 1909, a dedication service was conducted at the construction site of the new First Presbyterian Church at Fourth and Walnut Streets. The church was designed by William Pratt Feth. This magnificent structure, with its beautiful stained-glass windows, is one of the most visited and photographed in the city. In 2006, the church was listed in the National Register of Historic Places. (Courtesy Kenneth Spencer Research Library, University of Kansas Libraries.)

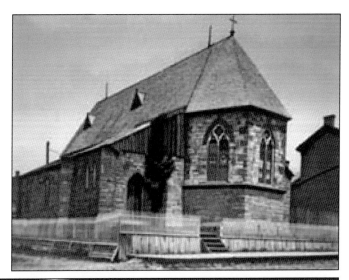

The first pastor of St. Paul's Lutheran Church arrived on November 9, 1861, organizing the congregation by March 9, 1862. In the fall of 1862, property was purchased on Delaware Street between Sixth and Seventh Streets, and the church was dedicated that Christmas. Land at Seventh and Miami Streets was purchased in 1866, and the current building (the third on this site) was dedicated December 10, 1911. (Courtesy Leavenworth Public Library.)

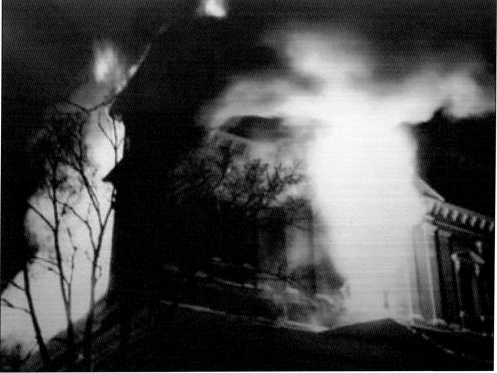

One of the saddest events in Leavenworth's church history occurred on December 30, 1961. Shortly after 1:00 a.m., Harold Needham, who lived at 520 Kiowa Street, saw flames coming out of the basement door of the Immaculate Conception Cathedral and immediately called the fire department. Leavenworth fire chief Bob Schroeder answered the call at his home at Seventh and Cheyenne Streets and ran the few short blocks to the cathedral. Upon arriving, Chief Schroeder called the Fort Leavenworth Fire Department for assistance. As firefighters arrived, they found the area of the sanctuary and main altar engulfed in flames. Over 35 firefighters were needed to contain the fire. The *Leavenworth Times* reported that all through the night, the temperature hovered around zero and scores of onlookers wept. (Author's collection.)

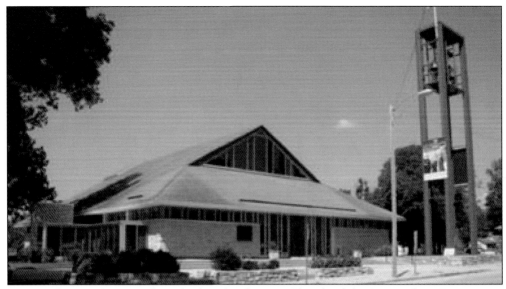

On March 31, 1963, ground was broken for the new Church of the Immaculate Conception. On October 20, the cornerstone to the new church was placed. By November 13, a 70-foot steel tower was raised, and on November 27, the three bells saved from the old cathedral were placed. On Sunday, May 31, 1964, Archbishop Edward Hunkeler conducted the dedication ceremonies, which included a blessing of the outside and inside of the new church and the first mass. (Author's collection.)

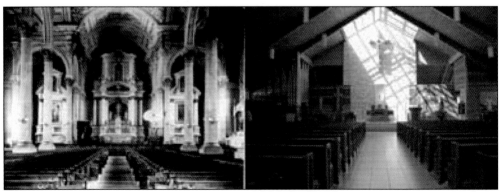

The altar of the old cathedral is seen at left shortly after dedication on December 8, 1868. On the right is the current altar and interior in the fall of 2016. (Left, courtesy Kenneth Spencer Research Library, University of Kansas Libraries; right, author's collection.)

Five
School Days

In May 1855, Rev. Josiah B. McAfee, a Lutheran minister, purchased a small building along the levee that originally housed a tin shop. He moved the building to the corner of Shawnee and Fifth Streets and used it as a classroom and for religious services. The original building was torn down and replaced with a two-story structure that was purchased by the City of Leavenworth and used as the first public school building. (Author's collection.)

On July 3, 1857, the first board of trustees met. The four trustees had established three school districts by October. The first ran from Seneca Street north to the Fort Leavenworth reserve, with classes in the Christian church between Osage and Pottawatomie Streets. The second ran from Seneca Street to Three Mile Creek, with classes in a rented room at the corner of Third and Delaware Streets. The third encompassed everything south of Three Mile Creek, with classes in the home of J. Robertson. In March 1859, Pennsylvania native Hugh D. McCarty (pictured) was appointed instructor of the second district school, and soon afterwards, he was elected city superintendent. A graduate of Franklin College in New Athens, Ohio, McCarty had taught in numerous common schools and the Morristown Seminary. While in charge of the seminary, he organized the first teachers' institute in eastern Ohio. He also served as the head of the high school at Flushing, Ohio, and the normal academy of Bedford, Ohio. By the fall of 1857, McCarty had come to Leavenworth and established a private school. During his tenure as superintendent, he established a curriculum and a grading system and erected many of the first school buildings in the city. In his annual report to the state in 1871, McCarty surmised, "A law compelling the daily attendance at school of every healthy boy and girl, for at least four months in the year, between the ages of seven and sixteen years, would have a most salutary effect. It is not only the imperative duty of the State to provide a full and free education, but to see that every son and daughter receive the benefit of that education." (Author's collection.)

In this c. 1856 photograph, the small building to the right was built by the Westminster Presbyterian Church and later acquired by the city. On the northwest corner of Seventh and Walnut Streets, this building housed the first high school in Kansas. To the left is the house of Richard Stevenson, a well-known photographer of the time. (Author's collection.)

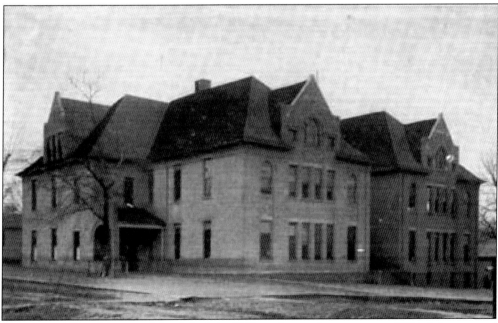

The original Third Avenue School, built in 1860 on the southwest corner of Third Avenue and Congress Street, served as one of the first primary schools in the Kansas Territory. It was expanded in 1865 and remodeled in 1895. By the time it was torn down in 1923, the school had served as the longest running primary school in the district. (Courtesy Leavenworth Public Schools.)

Built in 1866, the Sumner School stood on the corner of Fifth and Chestnut Streets. It was named in honor of Massachusetts senator Charles Sumner for his long stance against slavery and his famous "Crimes against Kansas" speech, delivered to Congress on May 19, 1856. (Courtesy Leavenworth Public Schools.)

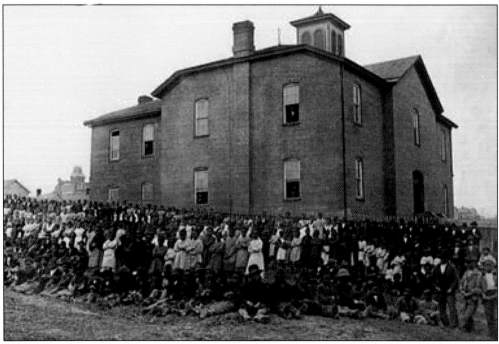

In 1867, the first permanent structure for African American pupils was built at the corner of Fourth Avenue and Prospect Street. Prior to the construction of the South Colored School, classes were held in the local Christian and Baptist churches. (Courtesy Leavenworth Public Schools.)

The North Colored School opened in 1868 at the corner of Third and Cheyenne Streets. According to the 1868–1869 city directory, the number of African American children between the ages of five and 21 was 924. The number enrolled in public school that year was 667. (Courtesy Leavenworth Public Schools.)

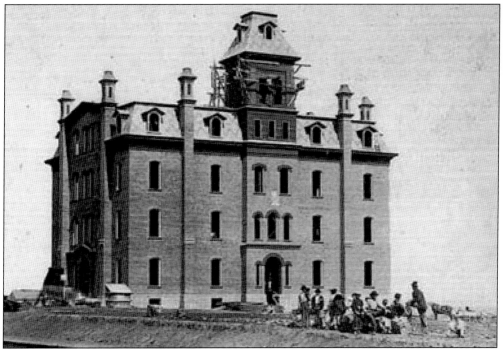

By 1869, the Morris School building at the corner of Fifth and Dakota Streets was completed and housed the grade school on the bottom two floors and the high school on the top floor. Originally a four-story building, the school sustained significant damage during a tornado in 1882, and the fourth floor was removed. (Courtesy Leavenworth Public Schools.)

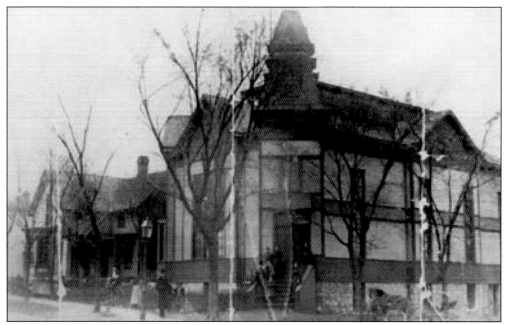

In 1872, the Kansas Conservatory of Music and Elocution and Collegiate and Primary School opened on the corner of Congress Street and Fifth Avenue. The course of study included playing many different instruments, reading music, and dance and theater. According to the school's advertisement, it provided teachers, private rooms, and instruments as well as a vast library of sheet music. (Courtesy Leavenworth Public Library.)

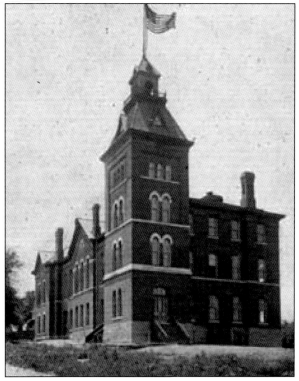

The Oak Street School served as the Leavenworth Public High School from 1874 through 1885. The curriculum consisted of arithmetic, elocution, natural philosophy, algebra, bookkeeping, physiology, commercial law, geometry, geography, chemistry, botany, astronomy, Greek, and Latin. In 1875, German, French, and Spanish were added. Other courses included political economy, meteorology, and trigonometry. (Courtesy Leavenworth Public Schools.)

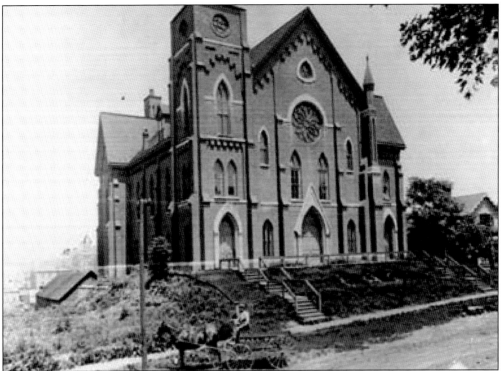

In 1886, the high school was moved into this building on the north side of Walnut Street between Fourth and Fifth Streets, the former Westminster Church. Classes were conducted on the assembly room plan, where all students gathered in one room and while one group was reciting, the other attempted to study. The high school remained here until 1904, when the building at Fourth and Chestnut Streets opened. (Courtesy Leavenworth Public Schools.)

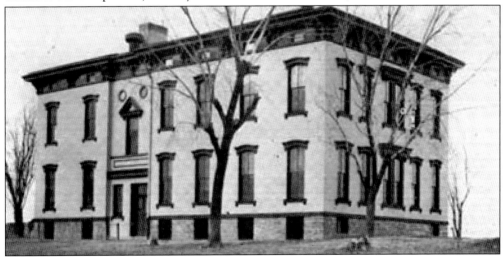

The Maplewood Seminary was built in the late 1860s and educated young ladies from all over the Midwest and as far west as California. By the 1880s, the school had closed, and the building served as an asylum until it was purchased by the Leavenworth Board of Education in the 1890s. Located on the corner of Olive and Grand Avenues, the school served the students who lived in the southwest portion of the city. (Courtesy Leavenworth Public Schools.)

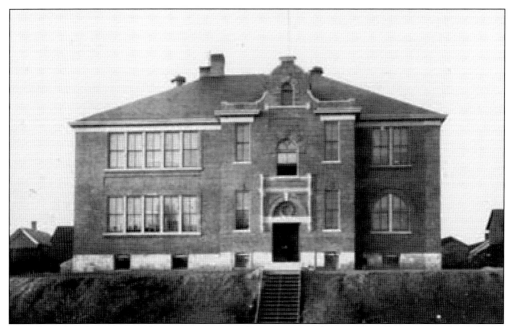
Lincoln School was opened in 1903 at 616 Dakota Street. The people of Leavenworth chose to name the school after Abraham Lincoln to honor the late president for his fight against slavery. (Courtesy Leavenworth Public Schools.)

Built in 1903, Jefferson School was on the corner of Eleventh and Kickapoo Streets and served as an elementary school. (Courtesy Leavenworth Public Schools.)

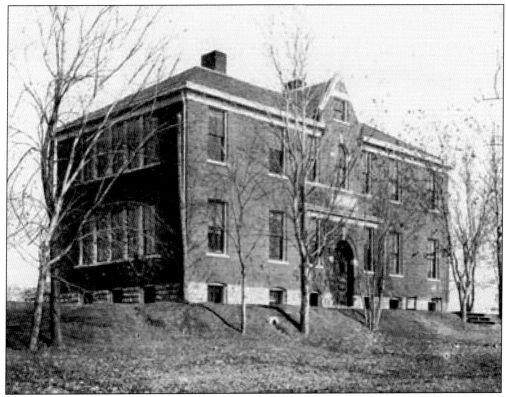
The Franklin School opened in 1903 at the corner of Ninth and Arthur Streets. It also served as an elementary school. (Courtesy Leavenworth Public Schools.)

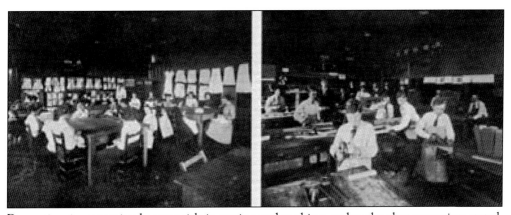
Domestic sciences trained young girls in sewing and cooking, and as the class supervisor stated, they "banish the so-called drudgery from the home." Classes in the manual school began in first grade, teaching boys the art of folding and cutting paper, the necessary principles in construction. Second grade taught basic sewing on art canvas. Third grade taught weaving on hand looms. Fourth grade taught raffia and rattan to develop artistic and adaptive instincts. Fifth grade taught cardboard construction, designed to introduce mechanical drawing, measuring, and cutting, necessary skills in construction and factory work. Sixth grade taught knife work in the school room. Seventh and eighth grades concentrated on bench work in wood. (Courtesy Leavenworth Public Schools.)

In 1907, the Wilson School opened its doors. This elementary school served students in the southwest section of Leavenworth and was in an area bounded by Vilas Street on the north, Wilson Avenue on the west, Logan Street on the south, and Franklin Street on the east. (Courtesy Leavenworth Public Schools.)

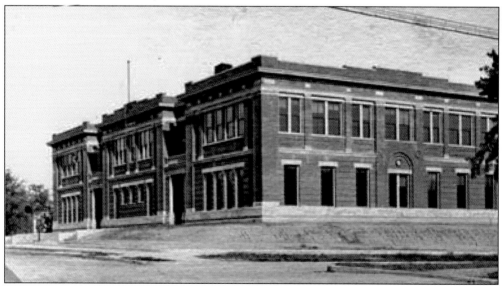

In 1904, Leavenworth Senior High opened its doors at the corner of Fourth and Chestnut Streets. William P. Feth designed the main building, and the R.B. Yoakum Company constructed it for $60,000. The west section contained the offices of the Leavenworth Board of Education and superintendent of schools. As the population of the high school increased and more classrooms were needed, a northwest wing was added (1913), and the board of education and superintendent's offices were relocated in the *Leavenworth Times* building on Main Street. (Courtesy Leavenworth Public Schools.)

On April 19, 1923, the Abeles family presented the board of education with 12 acres for a multisport facility. The stadium was dedicated on September 12, 1928, preceding the first home football game. The Leavenworth High football team, established in 1903, had previously played in various locations. In 1932, the archway was built honoring the late Morris Abeles. It provided two separate ticket windows and men's and women's comfort stations. The stadium was originally designed for football, baseball, and track and field. Lights were added in 1931. Until it closed in 1998, Abeles Field supported home football games for the Leavenworth Pioneers, Immaculata Raiders, and University of St. Mary Spires. (Courtesy Leavenworth Public Schools.)

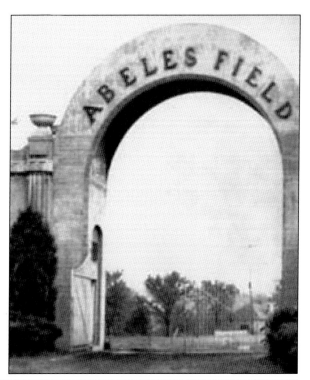

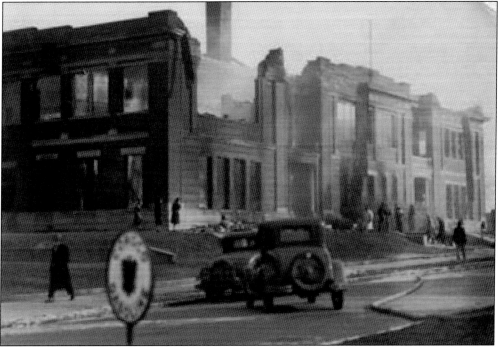

On January 29, 1932, the high school was destroyed by fire. At 1:20 a.m., residents along Chestnut Street reported flames shooting through the roof of the school. By the time firefighters arrived, the school was totally engulfed. The Fort Leavenworth Fire Department was called in to assist, and by dawn, it was apparent that the school was a total loss. (Courtesy Leavenworth Public Schools.)

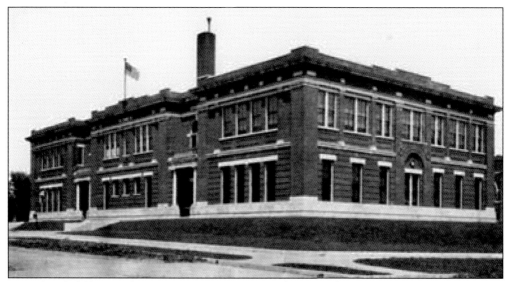

Immediately following the fire, citizens passed a bond issue authorizing the construction of the new high school on the same site. In the interim, students attended classes at the Oak Street School, with junior high students attending morning classes and juniors and seniors attending afternoon classes. Once completed, the $181,583, three-story building accommodated 800 students and had many modern features. The main-floor auditorium included a wired Vitaphone system, acoustical tiles, modern light fixtures, an orchestra pit, and, in the balcony, a movie projection booth. The gymnasium accommodated 1,000 spectators and featured an electric scoreboard. The school was turned over to the board of education on March 15, 1933, and the first classes were held in the new building on April 10, 1933. (Author's collection.)

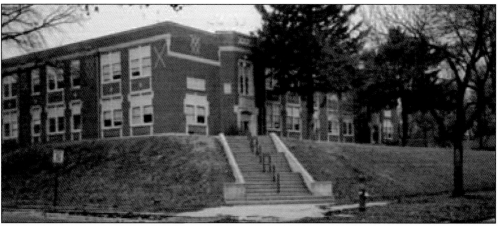

By the 1920s, many of the schools in the district had become inadequate to accommodate a growing population, and several of the oldest structures were not cost effective to renovate. In 1922, the North Broadway School was built between Dakota and Kiowa Streets facing North Broadway. Students from the Morris School were incorporated into the North Broadway School, and the Morris School was razed in 1923. (Author's collection.)

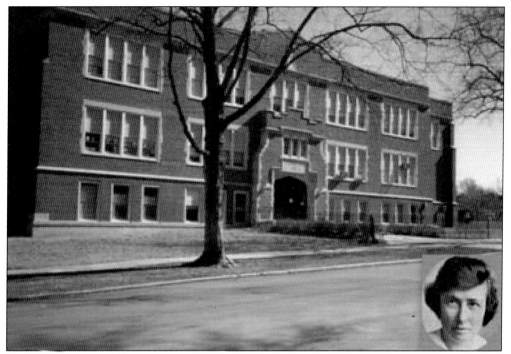

In 1923, Leavenworth Junior High School opened at the corner of Third Avenue and Congress Street. In 1959, when the new Leavenworth High opened, the old high school at Fourth and Chestnut Streets became East Junior High School. This building was used for several years as the Seventh-Grade Center until it became the Nettie Hartnett Elementary School in 1969. A district employee of 49 years, Hartnett (inset) began her career in 1911 in the high school principal's office and eventually became the registrar. When the Fifth Avenue School closed in 1970, its students began attending Nettie Hartnett Elementary. (Courtesy Leavenworth Public Schools.)

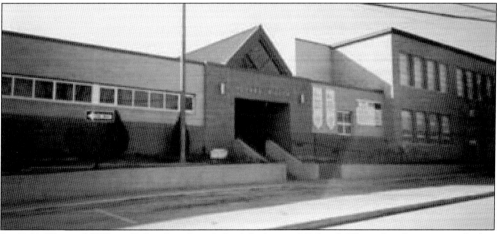

In 1941, Howard Wilson School replaced the Maplewood School. The school was named after a longtime resident, school board member, and Kansas senator. Wilson was born in 1858 and lived in Leavenworth until 1890. After moving to Mobile, Alabama, he built that city's first electric railway and became president of the Mobile Light & Railroad Company. Additions and renovations were completed in 1950, 1967, and 1992. The school was designated to be closed by public hearing on December 14, 2009. (Courtesy Leavenworth Public Schools.)

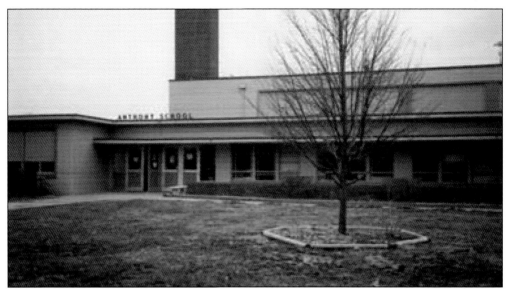

Anthony Elementary was built with funds from the Ford Foundation in 1950. The school honors four generations of the Anthony family. D.R. Anthony Sr. arrived in Leavenworth in 1854 and fought to secure Kansas's entry into the Union as a Free State. Three generations of D.R. Anthony men served as newspaper editors, and Daniel Read Jr. served in the US House of Representatives from May 23, 1907, to March 3, 1929. Also honored was Susan B. Anthony, sister of D.R. Anthony Sr. This school replaced the Cleveland Park and Wilson Schools. (Courtesy Leavenworth Public Schools.)

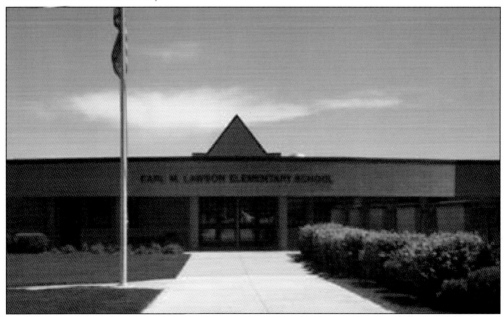

Earl M. Lawson Elementary School was also built in 1950. Lawson was an educator and principal who served 34 years at the historically black Lincoln School. He had grown up locally, attended the local schools, and graduated cum laude from Howard University. Lawson Elementary sits on the site of the former Lincoln School and replaced the North Broadway and Lincoln Schools. Additions and renovations to the school were completed in 1998. (Author's collection.)

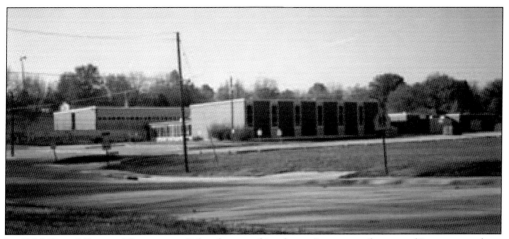

In 1956, David Brewer Elementary School opened its doors. Its namesake served Leavenworth as superintendent of the city and county schools and school board clerk. A lawyer by trade, Brewer came to Leavenworth in 1859 and was instrumental in forming the First Congregational Church. He later served as a US commissioner, a probate and district court judge, and Kansas Supreme Court judge. He was appointed a judge of the US Circuit Court in 1884 and was nominated to the US Supreme Court by Pres. Benjamin Harrison on December 4, 1889. He was confirmed by Congress on December 18 and served as an associate justice until his death on March 28, 1910. (Courtesy Leavenworth Public Schools.)

In 1959, the current Leavenworth High School opened its doors. The new facility replaced the high school at Third and Chestnut Streets, which became East Junior High School. The old junior high became Nettie Hartnett Elementary School. Renovations and additions were made in 1965, 1967, 1969, 1975, 1976, 1981, and 1990. (Author's collection.)

Built in 1969, West Junior High School served students living west of Tenth Avenue. By 2003, the school was known as the West Middle School and housed sixth through eighth grades. (Author's collection.)

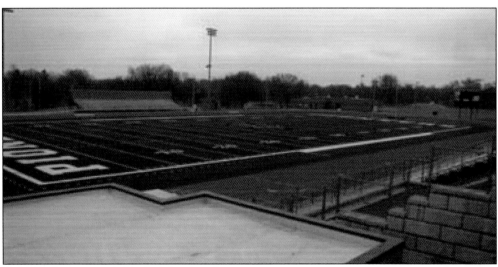

In 1998, Leavenworth High School underwent major renovations and updates. Along with additional classrooms, the renovations included a new state-of-the-art multipurpose facility for football, soccer, and track and field, a separate practice area for football and soccer, and an obstacle course for the JROTC program. (Author's collection.)

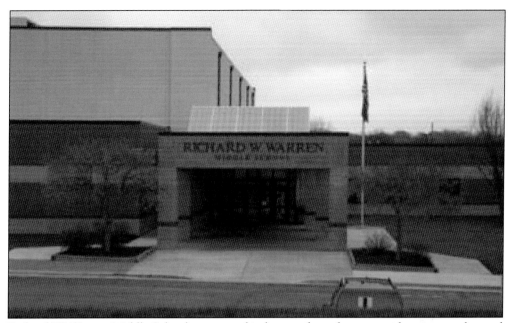

Richard W. Warren Middle School was named in honor of an educator, guidance counselor, and former principal of the Sumner School. Upon Warren's opening in 2000, East Middle School was closed, followed a few years later by West Middle School. Encompassing grades six through eight, the school studies consist of language arts, mathematics, science, and social studies, along with a wide range of student electives. (Author's collection.)

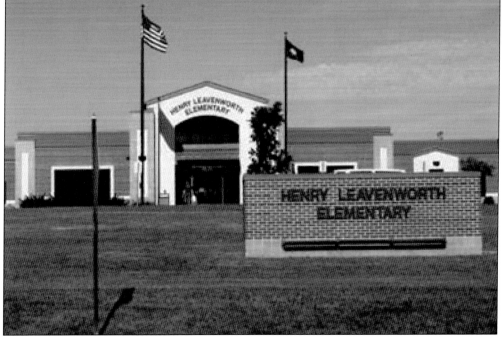

The newest school in the district is Henry Leavenworth Elementary. Named for the founder of nearby Fort Leavenworth and namesake of the city, it opened in 2010. The school features a state-of-the-art media center, art studio, and gymnasium. (Author's collection.)

In 1863, St. Paul's Lutheran Church established one of the first faith-based schools in the city. Though missionaries provided schooling for children and Native Americans at the fort, and other small private schools had operated prior to the establishment of the city school system, this was the first entirely operated and funded in association with a church. The school building at Seventh and Osage Street is pictured about 1894. (Courtesy Leavenworth Public Library.)

The first formal Catholic school was held on the first floor of the original St. Joseph's Church on Osage Street in 1859. Other Catholic schools were established at the old cathedral and at St. Casimir and Sacred Heart Parishes. The first Catholic High School classes were conducted in September 1909 at the old cathedral. As the schools' population increased, Monsignor Bernard Kelly developed plans for a large, centrally located Catholic school. The cornerstone of Immaculata High School was laid on May 21, 1923. The elementary schools of the four churches combined to create the Leavenworth Regional Catholic Schools in 1979. (Courtesy Leavenworth Regional Catholic Schools.)

Six

Western Branch National Home for Disabled Volunteer Soldiers

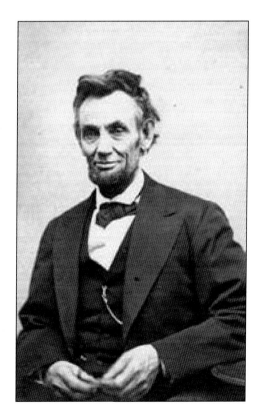

"With malice toward none, with charity for all, with firmness in the right as God gives us to see the right, let us strive on to finish the work we are in, to bind up the nation's wounds, to care for him who shall have borne the battle and for his widow, and his orphan, to do all which may achieve and cherish a just and lasting peace among ourselves and with all nations." President Lincoln during his second inauguration speech affirmed the government's obligation to care for those injured during the war and to provide for the families of those who perished on the battlefield. In 1893, the Grand Army of the Republic lobbied for a veterans' home west of the Mississippi River. Congress approved funding for a western branch to serve Arkansas, Colorado, Iowa, Kansas, Minnesota, Missouri, and Nebraska. (Courtesy Library of Congress.)

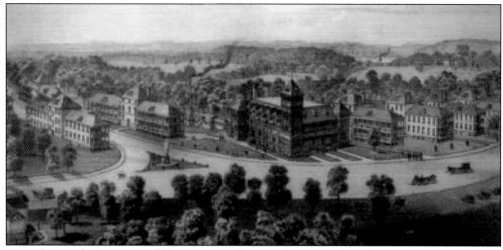

According to the *Leavenworth Times*, September 28, 1884, was a day of spontaneous celebration. Church and school bells rang out and over 1,000 locals paraded through downtown. Leavenworth had rallied for a veterans' home to care for the aging military residents of the region, and the city had finally received word that it had beaten out sites in six others states as well as several other possibilities in Kansas. The city had pledged $50,000 and free land. It would soon learn that the site would require over 600 acres and that the state government would not assist in any way with the money promised. (Author's collection.)

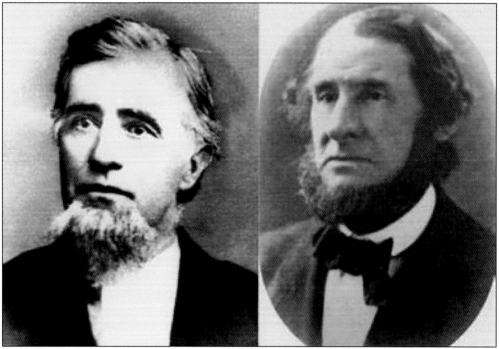

After negotiating payment of the $50,000 over 10 years, the board of managers chose James McGonigle (left) to design and construct the buildings and Horace William Shaler Cleveland (right) to design the landscape. The site was originally the Stockbridge Baptist Mission and a Native American cemetery (1844–1848) situated on a bluff overlooking the Missouri River. (Left, courtesy Leavenworth Public Leavenworth Library; right, author's collection.)

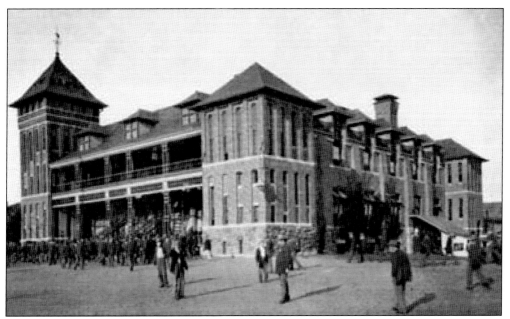

During the first phase (1885–1890), 17 buildings were constructed. These conformed to H.W.S. Cleveland's landscape layout. Each was constructed of brick formed from the clay found at the construction site. Central to the landscape and architecture, the first building completed was the mess hall and kitchen, named Franklin Hall. The design is Romanesque Revival and features a two-story porch supported by iron columns. (Author's collection.)

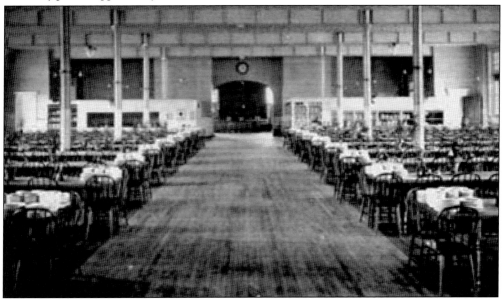

One of the earliest views of Franklin Hall shows its main dining room. The barracks housed 1,000 men, and the dining room could serve them all at one sitting. The facility was self-sustaining into the early 1900s, due in part to running its own dairy and gardening operations. The dining hall was on the main level, with a dance hall on the second level. A large raised stage was at the east end of the second floor. An auxiliary mess hall was constructed in 1908 between barracks buildings 11 and 12. (Author's collection.)

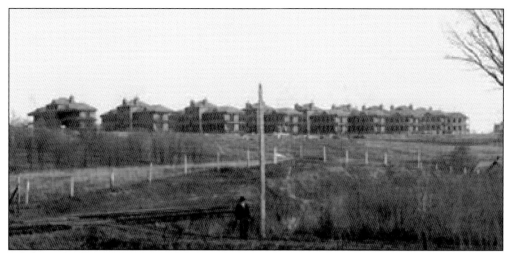

Of the 17 buildings constructed during the first phase, 13 were barracks. All were Georgian Revival. Each of the barracks features a central building three stories high with wings projecting from both sides. The west facades face Franklin Avenue (originally known as Front Street), and the east facades face the Midway (originally known as Back Street). A lawn and flower beds are between each barracks. A vast porch surrounds the second and third floors around three sides of each barracks and provides ample breezes and a stunning view of the surrounding vistas. (Author's collection.)

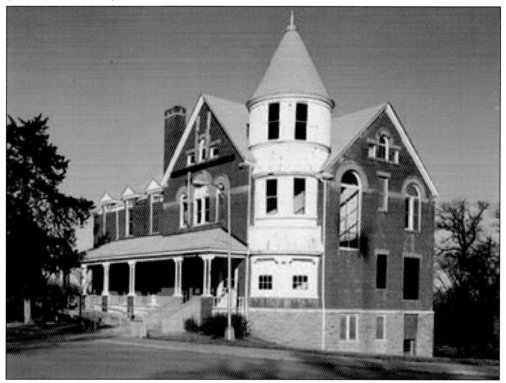

The Ward Memorial Building was completed in 1888. This Queen Anne–style building originally served as the cultural, administrative, and recreational center for the facility. (Author's collection.)

The Ward Memorial Building originally contained a large stained-glass portrait of Abraham Lincoln. The window hung between the first and second floors on the south side of the building and was presented during the annual encampment of the Grand Army of the Republic from the citizens of St. Louis. To preserve the window, it was removed and encased and is now on display on the second floor of the new domiciliary building, constructed in the mid-1990s. (Author's collection.)

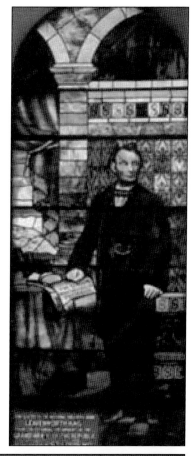

Designed by architects Louis Curtis and Fredrick C. Dunn of Kansas City, the chapel building, often referred to as Immanuel Chapel, is built in the late Gothic Revival style. When construction was completed in 1893, the building housed a Protestant chapel upstairs and a Catholic chapel downstairs. (Courtesy Library of Congress.)

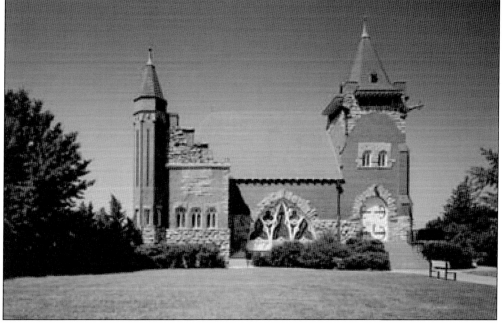

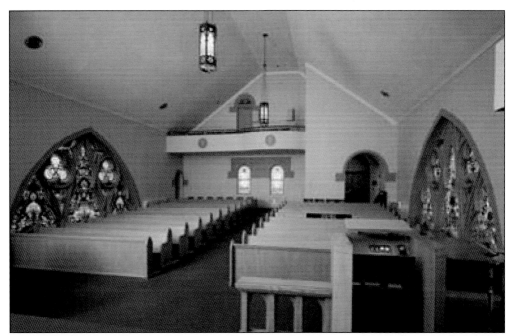
This interior view of the Protestant chapel features arched Gothic stained-glass windows on the east and west sides. The windows depict religious and patriotic themes with panels containing the initials WBNHDVS for the Western Branch of the National Home for Disabled Volunteer Soldiers. A rose window is on the south side. (Courtesy Library of Congress.)

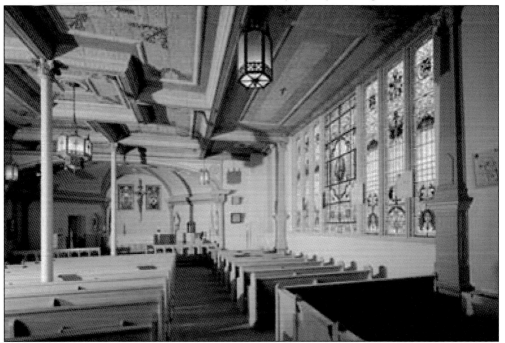
The interior of the Catholic chapel is elaborately detailed, featuring a coffered metal ceiling, statuary, stations of the cross, and a stained-glass window on the west side. (Courtesy Library of Congress.)

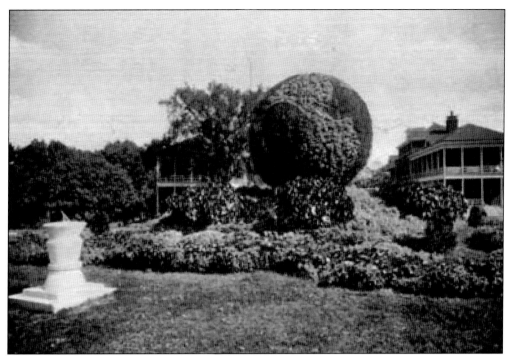

This floral globe, which stood at the intersection of Franklin and Riverview Avenues, was constructed around 1900 of chicken wire and topiaries. The globe stood for several decades, drawing the attention of all who lived and visited there. (Author's collection.)

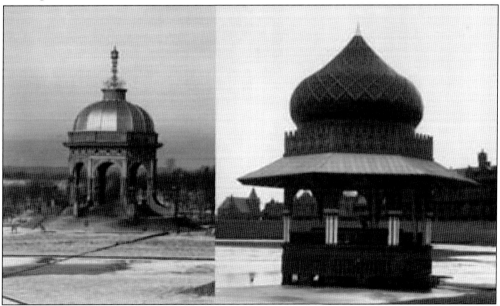

In 1887, a small bandstand was erected directly across the street from Franklin Hall. It was replaced in 1898 by the elaborate, domed bandstand on the left. The bandstand on the right, an exotic onion-domed structure, stood on Lake Jeanette and was built in 1890. The bandstand on the left was removed in 1964, and the Lake Jeanette bandstand was removed in 1934 due to deterioration. (Courtesy Kenneth Spenser Research Library, University of Kansas Libraries.)

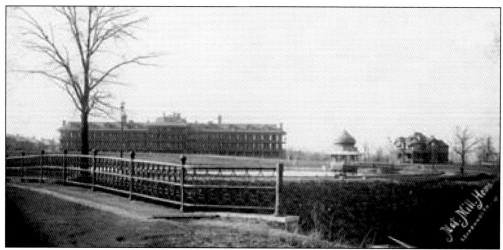

Construction began on the main hospital facility in 1885 and was completed in 1886. An expanded version of the original barracks, it featured a central building with wings extending from both sides. Surrounding the wings on all sides was a large, two-story porch. A convalescent barracks and hospital annex were also erected in this area. The original hospital building was torn down following the completion of the new hospital in 1933. (Author's collection.)

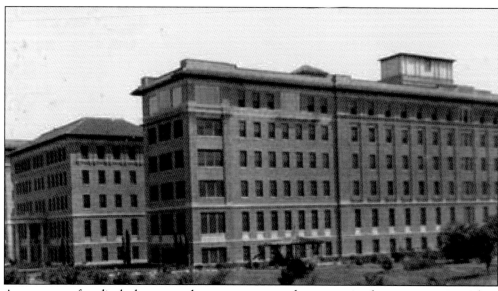

As a new age of medical advances and treatments emerged, construction began on a more modern hospital facility. Comprising four separate buildings connected by a series of hallways, Buildings 89, 90, and 91 are all built parallel to each other, while Building 88 is behind and connected to the rear of Building 89. Building 88 is the administration and clinical portion of the facility, and it is the most ornate, featuring a half-round limestone portico flanked by Ionic columns and a balustrade. Construction began in 1931 and was completed by 1933. This series of buildings ranges from four to six stories. Prior to construction, the governors' and quartermasters' quarters were moved to their current location just inside the west entrance. (Author's collection.)

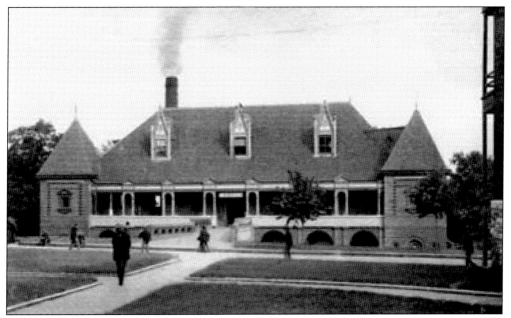

In 1898, the Recreation Hall, also known as the Dugout, was built into the side of a steeply sloped hill. This Chateauesque building is accessed across an arched brick bridge. Through the years, it has been used as a beer hall and post commissary, and in 1946, bowling alleys were installed on the lower level. In later years, the building served as a credit union and post office. (Author's collection.)

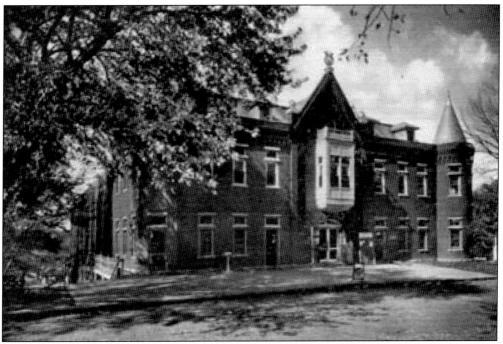

This hotel, store, and theater building was constructed in 1900 in the Romanesque style and featured drip-molding cornices and a round corner tower. The hotel closed in 1946, and the building was demolished in 1959. (Author's collection.)

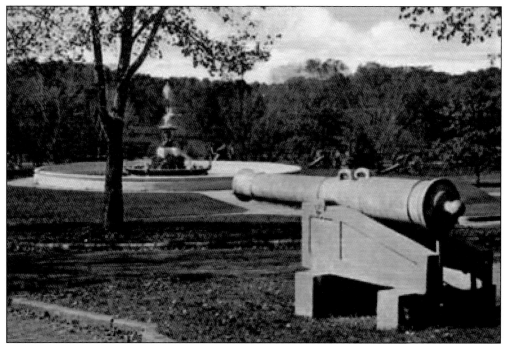
Incorporated into the landscape of the facility were 60 Spanish cannons captured from the fort of San Felipe. Adm. George Dewey took the fort at the Battle of Manila Bay during the Spanish-American War. Two fountains were also incorporated. One was a soldier's statue and water fountain, while the other was a large fountain surrounded by a man-made pond. This fountain was donated by the Anheuser-Busch Company of St. Louis. All have been removed except for one Spanish cannon that remains today. (Author's collection.)

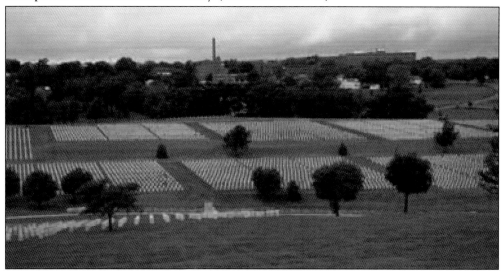
One of the most serene elements of the complex is the 164-acre Leavenworth National Cemetery. The park-like design amidst rolling hills is the final resting place for nearly 41,000 service members and families. Included are the remains of 12 unidentified Native Americans discovered during initial construction, and service members from the Indian Wars to the present. Also interred here are the remains of six Medal of Honor recipients. (Author's collection.)

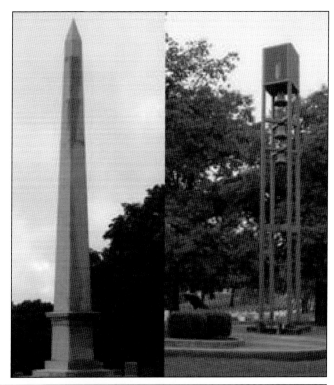

The Obelisk was constructed of solid limestone in 1919 at the cemetery's highest point, overlooking the Missouri River. It includes the words "In Memory of the Men Who Offered Their Lives in Defense of Their Country." The Carillon Plaza stands close to the Obelisk and features an open-air tower with three bells of different sizes. A granite monument with bronze medallions honoring the five branches of the military adorns one side. The three bronze panels on the reverse feature the lyrics to "Taps," the officers of the Leavenworth National Cemetery Carillon Memorial Corporation, and a quote from Pres. Harry Truman: "As these bells ring . . . honored dead rest . . . Freedom lives." (Author's collection.)

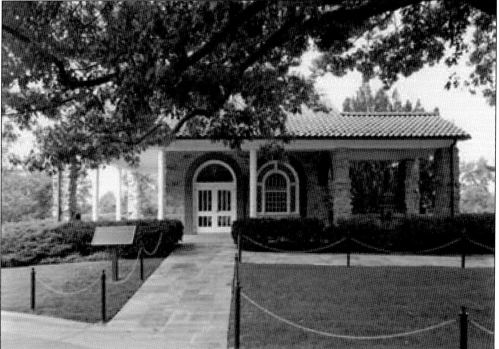

The Cemetery Rest House was erected in 1921. It was constructed in the Spanish Eclectic style of rough-faced limestone with a terra cotta roof, a covered seating area, french doors, and arched multi-light windows. (Author's collection.)

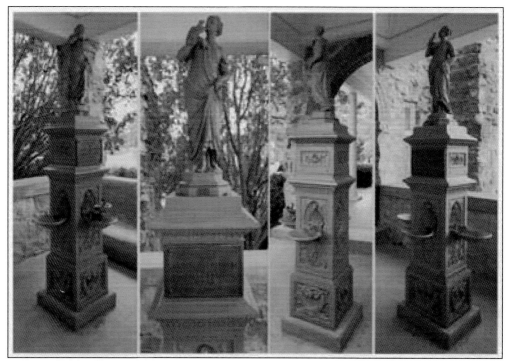

The covered seating area of the Cemetery Rest House contains this ornate cast iron water fountain. All four sides feature animal and plant motifs, and the fountain is adorned at the top by a statue of a woman holding a dove. An attached plaque reads: "Presented by the members and officers of the Wester Branch NHDVS May 30, 1931." (Author's collection.)

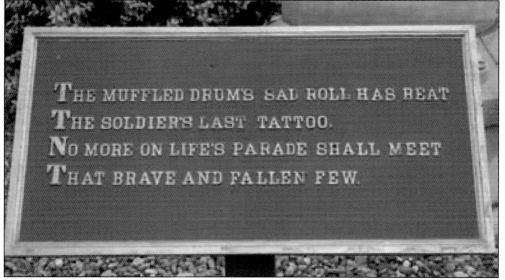

At various points throughout the cemetery are plaques depicting a poem by Danville, Kentucky, native Theodore O'Hara. Titled "Bivouac of the Dead," this poem was written to honor the Kentucky natives who fell in battle during the Mexican-American War. These plaques predate the 1930s. Various verses of this poem are featured in American national cemeteries worldwide. (Author's collection.)

A new 116,000-square-foot, three-wing domiciliary designed by the architect firm of Wilson & Company was built in the mid-1990s. Two of the three wings contain 208 patient rooms. The third wing contains administrative offices, staff facilities, a kitchen, and a dining facility. The domiciliary is connected to the main hospital by a 250-foot-long enclosed corridor allowing staff and patients to move between buildings in any type of weather. (Author's collection.)

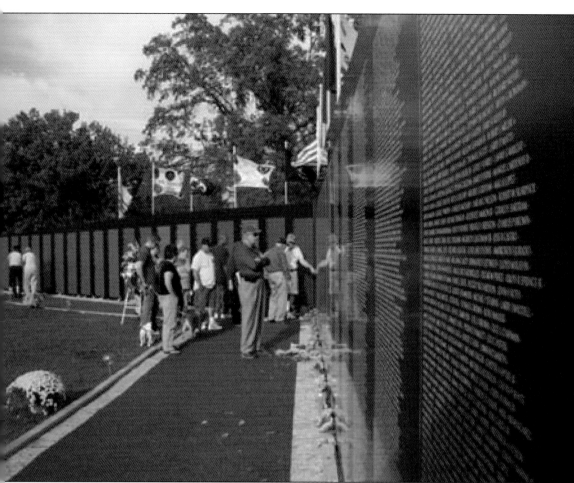

Just outside the main gates is an area known as Ray Miller Park. This area has hosted many different events, and in October 2016, the Veterans Administration hosted the traveling Vietnam Memorial Wall. The exhibit allowed locals a chance to pay their respects to those brave men and women who gave their life for their country. (Author's collection.)

Seven
HOMETOWN HEROES

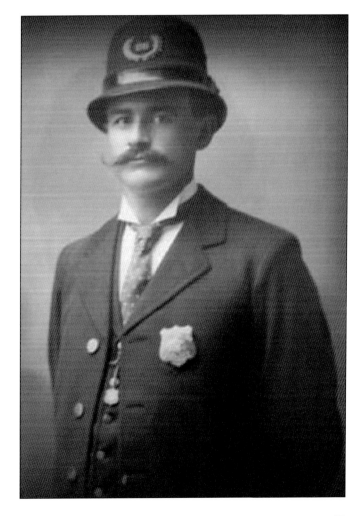

The job of keeping a community safe, from the early days of the territory to today, is a daunting task. Early on, a county sheriff, his deputies, and the Leavenworth Metropolitan Police discharged their duties tirelessly amid great personal peril, facing armed militias, Border Ruffians, and average criminals. Free Staters and pro-slavery men formed their own brand of law enforcement. The first election day saw a group of men walk amongst the crowd with strands of hemp tucked through a button hole identifying them as the "law and order" group. The first jail was purchased in November 1855, and E.K. Lowell, John Roundy, and J.B. Davis were hired as special policemen. They received $1.50 for every 12 hours worked. Pictured is a member of the Leavenworth Metropolitan Police force in the late 1890s to early 1900s. (Author's collection.)

The Leavenworth Fire Department was established on September 17, 1855. Miles Shannon was the first chief. Two fire districts were established, with Station One in city hall at the corner of Fifth and Shawnee Streets and Station Two at the corner of Fifth Avenue and Spruce Street. The first Leavenworth City Hall was constructed in 1858 and was originally called Market Hall. The Leavenworth Police Department moved into the building after 1872, after occupying its second location in an alley between Shawnee and Seneca Streets. (Courtesy Leavenworth Public Library.)

PUBLIC WARNING.

THE practice of discharging fire-arms within the limits of the city of Leavenworth, contrary to an ordinance of said city, having become so frequent as to endanger life and greatly annoy the quiet and peace of orderly citizens, I have taken this method to inform every one that I have determined to enforce the Ordinance against EACH AND EVERY VIOLATOR thereof; and if found necessary, will, by the authority of the Mayor, employ a secret police, for the purpose of giving information against every one thus offending.

WILLIAM P. SHOCKLEY,
City Marshal.
June 11, 1856.
Leavenworth City. [Leavenworth Journal Print.

This early handbill issued by Marshal William P. Shockley describes some of the problems the first city officers faced. The first murder in the territory was that of Malcolm Clark on April 30, 1855, during a squatters' meeting. Clark, acting as marshal, was attempting to restore order to the meeting and was fatally shot. Another meeting was held on May 25, 1855, by the Indignation Committee, brandishing its own justice. It ordered William Phillips shaved, tarred and feathered, ridden on a rail, and "sold by a negro" for the crime of moral perjury. Witnesses claimed Phillips was an accessory to Clark's murder and had lied about his involvement. (Author's collection.)

A March 6, 1932, *Leavenworth Times* article describes the city's lawlessness in the 1860s and the hiring of two famous lawmen. The town had been overrun by a band of border scouts known as Redlegs, organized in 1862 by Gen. Thomas Ewing and James Blunt for protection from the border guerillas in Missouri. The city hired frontier lawman Tom Allen (Thomas Allen Cullinan, left). Allen restored order within 30 days of his arrival; the town became boring, and he decided to move on. Then James Butler "Wild Bill" Hickok (right) arrived, famous as the West's greatest gunman. Cullinan was officially hired as a city marshal, but no records indicate that Hickok served Leavenworth in any official capacity. (Author's collection.)

Col. Thomas Moonlight was born in Forfarshire, Scotland, in 1833 and settled in Leavenworth in 1860 after serving in Texas with the US 4th Artillery Division. In 1861, Moonlight raised an artillery battery for the 4th Kansas Infantry that was assigned to the 1st Kansas Battery. He later joined the 11th Kansas Infantry as lieutenant colonel; when the company was reassigned as the 11th Kansas Cavalry, he was elevated to colonel. During the Civil War, he repelled border guerillas and bushwhackers. After the war, Moonlight returned to Leavenworth and served as the chief of police from 1867 to 1882. (Courtesy Library of Congress.)

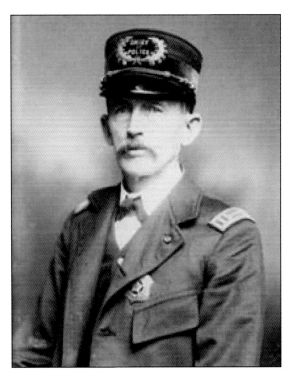

John T. Taylor was born in Cincinnati in 1841. His great-grandfather on his mother's side was Benjamin Harrison, a signer of the Declaration of Independence; his grandfather was William Henry Harrison, the ninth president; Benjamin Harrison, the 23rd president, was a cousin. Taylor served in the Civil War as the aide-de-camp to Gen. William T. Sherman and was injured at Vicksburg. At Shiloh, General Sherman's horse was shot out from under him; Captain Taylor immediately dismounted and surrendered his horse to the general. Taylor came to Kansas in 1866 and was engaged in farming and buying and selling land. (Author's collection.)

On May 8, 1866, Charles Quinn was fired from his job and shortly thereafter returned armed with a pistol and a large butcher knife, demanding to be paid for the time he had worked. The owner of the business said he would have to go to the bank. Officer John Curry walked up behind Quinn, put his hand on his shoulder, and placed him under arrest. Quinn spun with the knife, stabbing Curry in the chest right below the heart. As Curry fell, Quinn continued to stab him in the stomach. Curry was respected throughout the community and was described as quiet, efficient, and vigilant. Charles Quinn was taken around the corner of the jail on Chestnut Street and hanged. (Courtesy Leavenworth Public Library.)

This 1894 photograph shows members of the Leavenworth Police Department. From left to right are (first row) Eva Blackman (clerk), D. Coleman, Henry Jansen (police commissioner), Joe Cranston, Isaiah Langham, Frank Taylor, and John Roche; (second row) Cy Sprague (driver), Bill Shouse, and Bill Pickens. (Courtesy Leavenworth Public Library.)

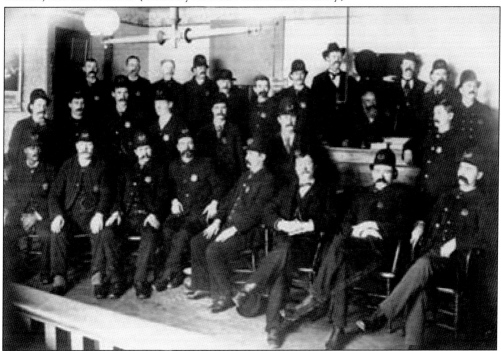

This 1894 photograph was taken inside police headquarters at Leavenworth City Hall at Fifth and Shawnee Streets. From left to right are (first row) George Craig, Charles Miller, Bill Schroeder, two unidentified, Joe Cranston, Bill Shouse, and Frank Taylor; (second row) Frank Bascus, Mickey Binon, Pat Delaney, Okie Prather, Judge Peter Carroll, and Isaiah Langham; (third row) Tom Larkin, Jerry Murphy, George Bammer, Chief William Pickens, John Roach, and Cy Sprague. (Courtesy Leavenworth Public Library.)

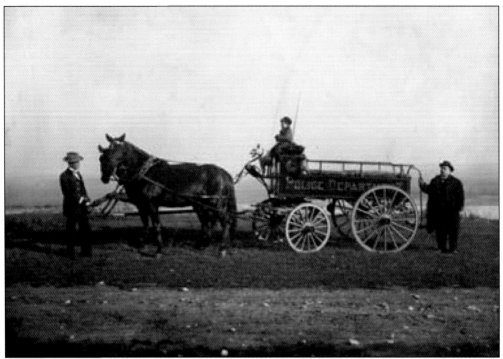

The "hoodlum and hurry up wagon" is pictured with, from left to right, Mike McDonald, Lorenzo Mella, and Frank Mella. (Courtesy Leavenworth Public Library.)

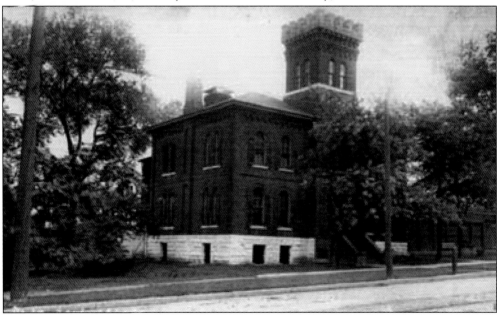

In the early days of the territory, when people were arrested, they were often confined to rooms in local hotels or boardinghouses. The city's first jail was in an alley just off Fifth Street between Delaware and Shawnee Streets, with a second location in another alley between Shawnee and Seneca Streets. The pictured jail was in an alley between Choctaw and Cherokee Streets running from Second Street to Third Street. (Author's collection.)

About 2:00 p.m. on January 13, 1910, officers responded to shots fired near Second and Cherokee Streets. An argument the previous day over money Joe Lacy owed Jinks Proctor led to the shooting. The search for Proctor led officers Warren G. Devinish, Henry Hubbard, and Patrick Sweeney to a room occupied by a woman named Willie Jackson at 312 Choctaw Street. Sweeney entered first, followed by Devinish, who spotted Proctor and ordered him to put his hands up. As Proctor raised his hands, gunfire erupted. Devinish was mortally shot through the forehead and right arm. Sweeney was also wounded. Proctor was sentenced for the murder of Devinish. (Courtesy Leavenworth Public Library.)

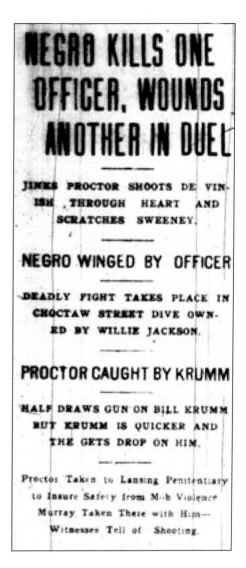

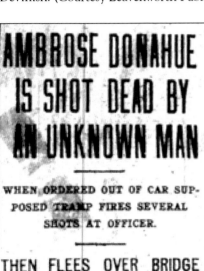

About 11:00 p.m. on July 2, 1910, merchant police officer Ambrose Donahue responded to shots fired in the Missouri Pacific railyard. Accompanied by Rude Przyblowicz, William Leemer, and W.B. Thomas, a special agent with the railroad, Donahue searched the yard for a man seen firing a gun. During the search, the unidentified suspect fired at the officers and fled. Around two hours later, the officers found the suspect hiding face down in a boxcar. He was ordered to surrender, and as he rolled over and sat up, he opened fire. Officer Donahue, though struck several times, returned fire. The suspect was last seen running with a limp east over the terminal bridge. (Courtesy Leavenworth Public Library.)

JOY-RIDERS FACE SERIOUS CHARGE; COUPLE AT LARGE

SCHAEFFER ARRESTED, GODFREYS SURRENDERED, BUT OTHER TWO AT LARGE.

SAY STARNES WILL RECOVER

In Exciting Chase Sunday Night, James Thompson, Railroad Detective, Shot Driver of Pursued Car Through Right Index Finger —$5,000 for Two of Three Men Taken into Custody Are Signed by Party of Farmers Who Live Near Lowemont.

Around 8:00 p.m. on July 15, 1919, officers responded to an accident at the corner of Fifth and Shawnee Streets. They had received several complaints about an automobile occupied by five men joyriding through the streets and almost causing several accidents. When officer John Starnes arrived, the men attempted to flee, and as they pulled away, Starnes jumped on the running board. One of the suspects struck Starnes in the head with a crankshaft, causing him to fall from the moving vehicle. Starnes was taken to a local hospital but succumbed to his injuries seven days later. (Courtesy Leavenworth Public Library.)

WOUND FATAL TO ERNEST GOUGH POLICE OFFICER

End Comes at 2:30 o'Clock This Afternoon to Detective Shot Last Night.

FIRES WITHOUT WARNING

Officers Gough and Feidler Approached Two Men Hiding Behind Tree and Drew Immediate Fire.

About 10:30 p.m. on July 29, 1932, officers Joseph Fiedler and Ernest Gough spotted two men crouched behind a tree near Seventh Street and Broadway. The officers exited their patrol vehicle, approached the suspects, and ordered the men to stand up. One of the suspects reached in his pocket, produced a .45 caliber semi-automatic pistol, and opened fire. Gough was struck in the abdomen by a single bullet, mortally wounding the patrolman. (Courtesy Leavenworth Public Library.)

Around 8:25 p.m. on October 28, 1925, officers E. Clay Thompson and Dennis Polk were patrolling the south section of town. They were walking north on Second Avenue between Reese Street and Buttinger Avenue when a car driven by 20-year-old Henry A. Klemp struck Thompson from behind. Klemp and his mother, who was a passenger in the car, stopped immediately. Thompson was pinned underneath the vehicle, under the differential. S.E. Johnson, a railroad employee, was passing buy, loaded the officer into his vehicle, and drove him to St. John's Hospital. Thompson succumbed to his injuries in surgery approximately 30 minutes after the accident. (Author's collection.)

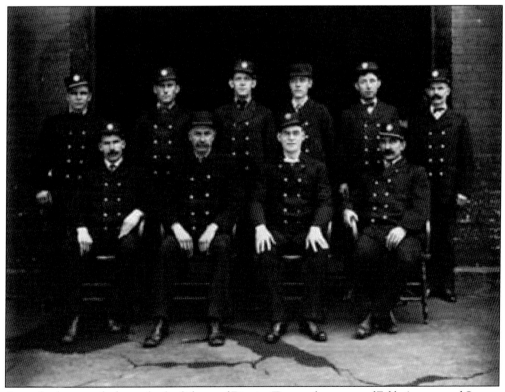

An early photograph shows the firefighters of District Two, at the corner of Fifth Avenue and Spruce Street. (Courtesy of Kenneth Spencer Research Library, University of Kansas Libraries.)

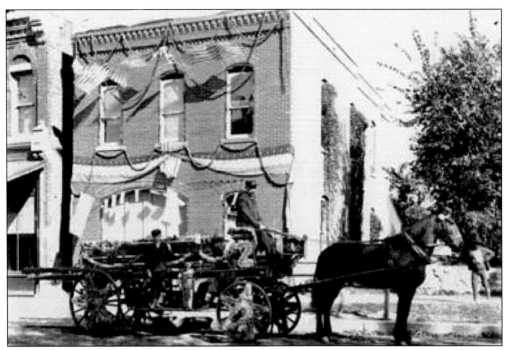

This early photograph shows the firefighters of District Two with the fire wagon decorated for the annual floral parade. Firefighter Bob McDoel is driving a wagon built by Bayer Brothers of Leavenworth. (Courtesy Kenneth Spencer Research Library, University of Kansas Libraries.)

Many of Leavenworth's original buildings have been severely damaged or destroyed by fires. On the evening of March 22, 1911, two workmen oiled the floors in the county court clerk's office on the first floor of the county courthouse. Later that evening, a fire was discovered by night watchman William Wissler, who immediately sounded the alarm. As firefighters arrived, the building was totally engulfed, and flames were already through the roof and clock tower. The fire was believed to be the result of a discarded match on the freshly oiled floor. It spread quickly, aided by a stiff wind that carried embers over other parts of the city. The building was a total loss, as were most of the county records and other contents. (Author's collection.)

Dated June 1, 1913, this postcard was distributed to every taxpayer of the city of Leavenworth explaining the cost of replacing the original courthouse. The building was designed by William P. Feth and still serves as the Leavenworth County Courthouse. (Author's collection.)

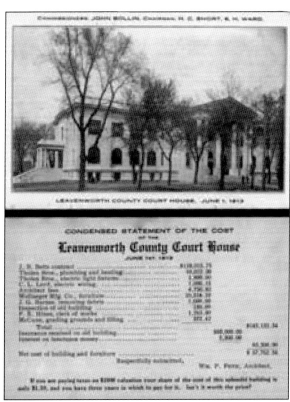

Construction on the new city hall was completed in 1925. One journalist explained, "the architecture, perfected by Feth & Feth in 1924 is classical. The building itself is constructed of reinforced concrete with terrazzo corridors." The building housed all the city offices, including the police and fire departments. It also housed the District One firehouse. The second floor contained an auditorium that sat 600. (Author's collection.)

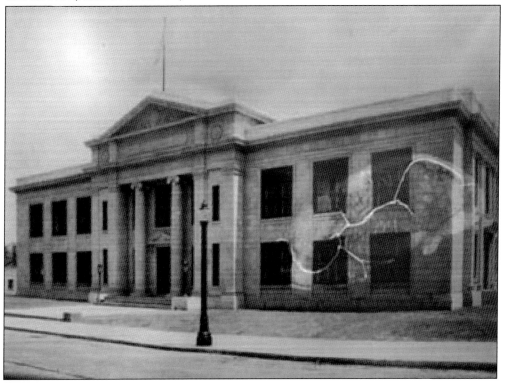

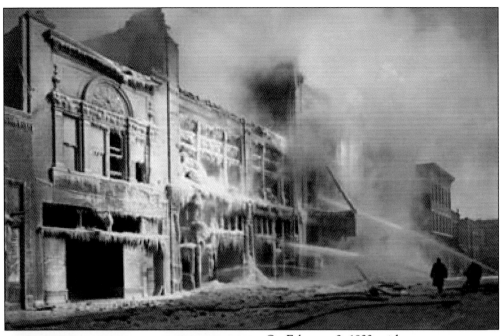

On February 2, 1933, with temperatures below zero, firefighters fought this blaze that destroyed much of the 300 block of Delaware Street. The fire significantly damaged or destroyed Endes & Kirkmeyer Cigar Store, Hub Clothing, Orpheum Cleaners, Elma Café, and the Reagan Drug Store. (Author's collection.)

BAILEY BELL FALLS BEFORE BANDIT'S FIRE

Newly Appointed Colored Officer, Slain by Occupant Stolen Car Parked on Shrine Park Road Near Limit.

USES SAWEDOFF SHOTGUN

Slayer Escaped Under Rain of Bullets From Officer Hunt and Second Bandit Dashes From Nearby Store, Escaping.

About 1:30 a.m. on February 4, 1933, officers Kenneth Hunt and Bailey Bell spotted a car on the side of Shrine Park Road. Hunt recognized the license plate as belonging to a vehicle reported stolen earlier that evening. The officers exited their car and approached the stolen vehicle, and Hunt alerted Bell that someone was in it. As they approached, they ordered the suspect out of the car, and as he exited the vehicle, he opened fire on the officers with a sawed-off double-barrel shotgun. Bell was mortally wounded by the blast. Hunt opened fire on the suspect, who fled towards Maple Avenue and Limit Street, where he fell. At the time of his death, patrolman Bailey Bell had been with the department for three weeks. (Courtesy Leavenworth Public Library.)

In February 1939, Leavenworth firefighters fought several suspicious fires throughout the city. One fire on February 14 on Elm Street destroyed a garage and damaged three homes. While they were fighting the fire, a chimney fell, trapping John W. Feldheger and Arthur H. Connell. Feldheger, an 18-year fire department veteran, succumbed to his injuries on February 15, leaving behind a wife and a daughter. On February 16, Connell, a one-year veteran of the department who had formerly served as a police officer, also succumbed to his injuries, leaving behind a wife and three small children. (Author's collection.)

Officer Coldren Killed In Gun Battle Today

Patrolman Richard Coldren, 28, and a man identified as Charles Moburg, about 40, were killed in a gun battle at 6th and Kickapoo during the noon hour today. First reports to reach police headquarters indicated that the slain patrolman and Charles Pierce were pursuing a blue sedan on 6th. The officers were in separate cars. Pierce was not shot.

Around noon on March 19, 1957, patrolman Charles Pierce spotted a vehicle traveling north on Sixth Street driven by Charles Moburg, who was being sought on suspicion of trespassing that morning. A pursuit ensued, and Pierce was soon joined by patrolman Richard Coldren. As they reached Sixth and Kickapoo Streets, Coldren overtook Moburg's vehicle and ended the pursuit. As Pierce exited his car, he came face to face with Moburg pointing a pistol at his head. Coldren approached Moburg and attempted to grab him from behind. Moburg turned and fired, mortally wounding Coldren. As Coldren fell, he returned fire, killing Moburg. (Courtesy Leavenworth Public Library.)

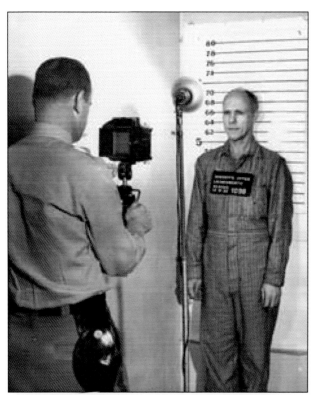

On December 29, 1956, the Leavenworth County Jail received one of the most notorious gang members from the 1930s. Bonnie and Clyde associate Floyd Hamilton had been released from the nearby federal prison after serving an 18-year sentence for bank robbery. Hamilton, facing a 5-to-25-year sentence in Texas, was booked into the jail. He is pictured having his mugshot taken by Deputy Sheriff Henry Campbell. (Author's collection.)

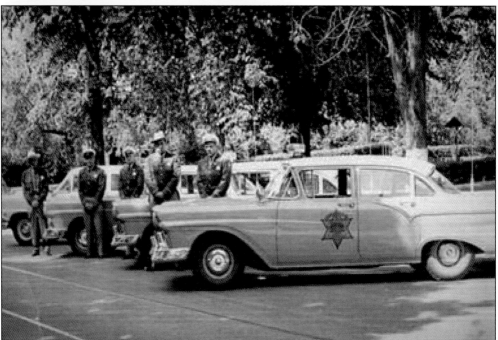

Members of the Leavenworth County Sheriff's Department are, from left to right, Arden Ryhne, Henry Campbell, unidentified, Sheriff Bob Woodson, and Elmer Parmer. (Courtesy Jim Campbell.)

The fourth county jail was at 503 South Third Street. Opened in 1939, this building served the local law enforcement community until 2000, when the new justice center opened. The local preservation society made efforts to maintain the building, but city officials decided to demolish the structure in December 2013. (Author's collection.)

On August 28, 1960, Deputy Elmer M. "Okie" Parmer pursued a vehicle driven by a suspected drunk driver eight miles southwest of Tonganoxie on Highway 24-40. During the chase, the vehicle swerved into oncoming traffic, striking a motorcycle and killing the 20-year-old driver. The vehicle came to rest in a ditch after striking a guy wire from a power pole. Deputy Parmer cleared debris from the roadway, aided by a truck driver. As he moved the guy wire, it came in contact with the high-voltage line, killing the deputy instantly. He was survived by his expectant wife, a son, and a daughter. (Author's collection.)

The Leavenworth Justice Center opened in 2000. The 160,581-square-foot, four-story complex features a 160-bed jail with the possibility of an expansion for an additional 96 beds. There are five jury courtrooms with possible expansion for three additional courtrooms. The building houses the city police department and the county sheriff's office, as well as support staff, the county attorney, victims' services, and other offices. (Author's collection.)

Eight
OUR HOME SWEET HOME

Aside from being one of the most historical cities in America, Leavenworth has been home to many who have risen to prominence in different fields. Whether it be music, movies, arts, sciences, sports, or on Broadway, many have stood on the world stage and made a difference. Probably the best known is Melissa Lou Etheridge. Born on May 29, 1961, Etheridge jumped onto the music scene with her self-titled debut album in 1988. Her single "Bring Me Some Water" saw huge success and garnered the singer's first of 15 Grammy nominations. The singer-songwriter has twice won the Grammy Award for Best Rock Performance, Female (1993, 1995) and won an Academy Award for Best Song. In September 2011, Melissa Etheridge earned her star on the Hollywood Walk of Fame. (Author's collection.)

William Pratt Feth, born in 1866, began his formal training under Erasmus T. Carr, a local architect and designer of numerous buildings on Fort Leavenworth, in Leavenworth, and in many other Kansas cities. Feth studied drafting at the Armor Mission in Chicago and worked for the Chicago firm of Burnham and Root. Returning to his hometown in 1895, he opened his own firm, and in 1920, his son William became his partner. (Courtesy Leavenworth Public Library.)

Hilda Clark was born in 1872 to Lydia and Milton Edward Clark. By her early 20s, she had become a noted understudy and leading operatic soprano and actress on the Boston stage. Her greatest fame came in 1895 as a model when she became the first woman to appear on a tin tray advertisement for Coca Cola. She remained the advertising face of Coke until 1903, when she wed Frederick Stanton Flower. She passed away on May 5, 1932, and in the world of Coca Cola collectables, her original merchandise remains the most highly sought after, collectable, and expensive worldwide. (Author's collection.)

Outfielder/first baseman Duff Gordon Cooley, born on March 29, 1873, played 13 seasons with the St. Louis Browns (1893–1896), Philadelphia Phillies (1896–1899), Pittsburg Pirates (1900), Boston Beaneaters (1901–1904), and Detroit Tigers (1905). His career stats include 1,317 games played, 1,579 hits, 26 home runs, 557 RBIs, 224 stolen bases, 849 runs scored, and a .294 career batting average. He was nicknamed "Sir Richard" for his aristocratic manner. In his final year, Cooley broke his leg and was replaced by Ty Cobb. (Author's collection.)

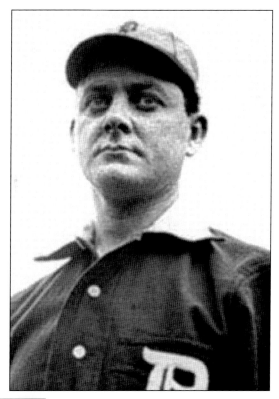

Composer and lyricist Charles N. Daniels, born on March 12, 1878, won his first award at 18 for "Margery." By 1899, Daniels had gained national fame and begun working for Kansas City music publisher Carl Hoffman. By 1904, he opened his own music publishing company in St. Louis. Daniels composed and published music under the names Neil Moret, Jules Lemare, L'Albert, Paul Bertrand, Julian Strauss, and Sydney Carter. His music has been featured in many movie soundtracks and television shows, including *The Postman Always Rings Twice* (1946), *I Love Lucy*, and *All in the Family*. (Author's collection.)

Eugene Burr (April 14, 1878–June 7, 1940) is credited with appearing in 34 movies from 1916 to 1938. His most noted were *Heiress of the Day*, *Old Hartwell's Club*, and *The Vortex*. This lobby card is from the 1928 film *The House of Terror*. From left to right are Eugene Burr, Dorothy Tallcott, Valerie Burr, and Pat J. O'Brien. (Author's collection.)

Herbert M. Woolf (October 11, 1880–September 22, 1964) was the son of Albert Woolf, cofounder of Woolf Brothers Department Stores. The company moved to Kansas City, and Herbert began working for it in 1912. By 1915, he was the president. Herbert Woolf indulged his passion for horses with the 200-acre retreat where he threw extravagant parties for the likes of Theodore Roosevelt and Tom Prendergast. In 1933, he purchased Insco, sire of the French racehorse Sir Gallahad III. Insco sired the 1938 Kentucky Derby winner Larwin, ridden by hall-of-fame jockey Eddie Arcaro. In 1940, Woolf's horse Insocolassie won the Kentucky Oaks. (Author's collection.)

Brock Pemberton (December 14, 1885–March 11, 1950) attended the College of Emporia and the University of Kansas. Pemberton began his career as a Broadway press agent writing for the *Evening Mail*, *New York World*, and *New York Times*. Abandoning journalism, he became an executive producer under New York stage director Arthur Hopkins. He was professional partners with Mary Antoinette "Toni" Perry, actress, director, and cofounder of the American Theater Wing. Pemberton is credited with founding the Tony Awards and naming them after his longtime partner. (Author's collection.)

Benjamin Currier "Ben" Hirschfield (December 7, 1888–November 22, 1963) was a talent agent and manager representing actors, writers, and directors in 1930s Hollywood. In 1935, while doing film work, he also served as a Los Angeles city councilman. In 1938, Herschfield produced a series of films titled *The Old Prospector* with his then wife Rita LaRoy (pictured). These were the first films to use the colorchrome color film process. Herschfield died in Los Angeles on the same day Pres. John F. Kennedy was assassinated. (Author's collection.)

William M. Boyle Jr. (February 2, 1902–August 30, 1961) was politically active by 16 and formed the Young Democrats Club. Kansas City political boss Tom Pendergast made him a precinct captain before his 21st birthday. As a lawyer, Boyle remained active in the Kansas City Democratic Party. He helped his very close friend Harry Truman in his successful 1934 Senate run. In 1944, he joined the Democratic National Committee and helped direct Truman's vice presidential campaign. In 1948, Boyle persuaded President Truman to embark on a whistle-stop train tour of the Midwest, the turning point that catapulted Truman to re-election. In 1949, Boyle became the Democratic National Committee executive director. By 1951, he was implicated in a scandal involving exerting pressure to secure loans for political allies. Two senate subcommittees split on whether Boyle was guilty of wrongdoing, but he admitted accepting fees from those loans. (Author's collection.)

Ralph Peters was born on August 3, 1902. He was an actor whose career spanned from 1936 to 1958 with 218 total credits, 201 motion pictures and 17 television appearances. Peters died on April 12, 1959, in Los Angeles. (Author's collection.)

Right-handed pitcher Chester Arthur "Chet" Brewer (January 14, 1907–March 26, 1990) played professionally for 24 years. In the Negro Leagues, he pitched for Gilkerson's Union Giants (1924); Kansas City Monarchs (1925–1935, 1937, 1940–1941, and 1946); Crookston, Minnesota (1931); Washington Pilots (1932); Brooklyn Royal Giants (1935); Bismarck, North Dakota (1935–1936); New York Cubans (1936); Philadelphia Stars (1941); Cleveland Buckeyes (1942–1943 and 1946–1948); and Chicago American Giants (1946). After his retirement from playing, he worked as a scout and instructor for the Pittsburgh Pirates (1957–1974). (Author's collection.)

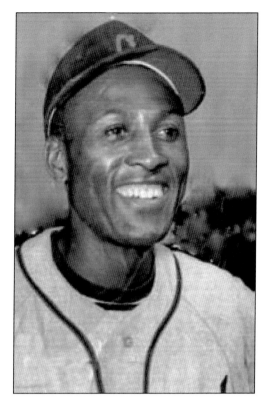

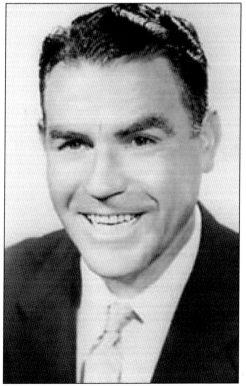

Roland "Kickapoo" Logan was born in 1908 and graduated from Leavenworth High School in 1926. He was a halfback on the University of Kansas football team and coached at West Point. During his World War II Navy service, he was the head trainer at the pre-flight school in Chapel Hill, North Carolina. From 1949 to 1958, he founded, edited, and published the magazine *Athletic Training News*, dedicated to athletic trainers. He served as an athletic trainer at George Washington University, University of Pittsburgh, University of North Carolina, the US Naval Academy, Pasadena College, and with the Boston Red Sox. He was elected to the National Athletic Trainers' Association Hall of Fame in 1971. (Author's collection.)

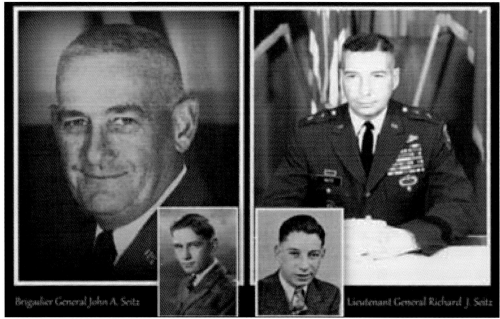

John (1908) and Richard Seitz (1918) were the sons of John Seitz, who owned and operated a wholesale milk and ice cream business and served as mayor. John attended the University of Kansas in its ROTC program. Richard attended Kansas State University in its ROTC program. Both served in World War II. Brig. Gen. John A. Seitz (left) retired in 1967 as commanding officer of Fort Riley, Kansas. Lt. Gen. Richard J. Seitz (right) served as the deputy chief and chief of staff in Vietnam and retired in 1975 as commanding officer of XVIII Airborne Corps at Fort Bragg, North Carolina. (Left, author's collection; right, courtesy 82nd Airborne Division War Memorial Museum; insets, courtesy Leavenworth Public Schools.)

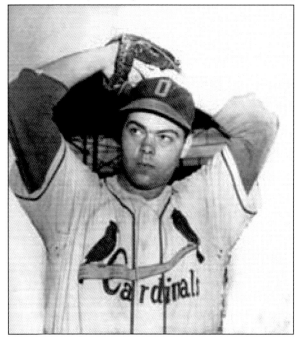

Walter "Wolf" Montgomery, born July 25, 1930, was recruited at the age of 17 by the St. Louis Cardinals and played professional baseball from 1948 to 1953. He also worked as a scout in the Baltimore Orioles organization. Montgomery covered sports for the *Leavenworth Times*, provided material for Johnny Carson and Joan Rivers on the *Tonight Show*, and was a published author and local businessman. (Courtesy Chris Henchek.)

Randy Sparks (born July 29, 1933) embarked on a solo career with a self-titled album (1958) and *Walking the Low Road* (1959). His single "Walking the Low Road" appeared in *Cashbox* magazine's top 60. In the early 1960s, he formed the Randy Sparks Trio and released a self-titled album. In 1963, he formed the New Christy Minstrels and released a self-titled album with Columbia Records. It peaked at number 19 on the Billboard charts and won a Grammy. The group disbanded in the early 1970s but reformed as Randy Sparks and the Minstrels. Randy and his wife, Diane, live in Mokelumne, California. (Courtesy Randy Sparks.)

Gary Foster (born May 25, 1936) plays saxophone, flute, and clarinet, performing jazz, pop, and classical. He began as a studio musician in Los Angeles in 1961. By 1973, Foster was playing with the Grammy-winning Los Angeles–based big band of Toshiko Akiyoshi and Lew Tabackin. Over five decades, Foster has appeared with the Los Angeles Philharmonic, the Los Angeles Chamber Orchestra, the Los Angeles Opera, and the Oscar Orchestra. He has appeared on over 500 movie scores and in 200 live and television orchestras. (Courtesy J. Cooper.)

Ron Logan (born February 9, 1938) studied trumpet, violin, piano, and dance and began performing professionally by the ninth grade. He has played trumpet and sung on multiple recordings as well as on television and in motion pictures. He began his career in 1960 as a trumpet player at Disneyland. As the executive vice president of Walt Disney Entertainment, he was responsible for creating, casting, and producing all live entertainment at all the Disney resorts, Disney Cruise Lines, and Disney entertainment and productions worldwide. In 2007, he was awarded the Disney Legends Award, given to those who have made a significant contribution to the Walt Disney Company. (Courtesy Ron Logan.)

Pat McMahon was born in 1933 to vaudeville performers Jack and Adelaide McMahon. He began traveling the world and performing with his parents at the age of five. His broadcasting career began while he was attending Ambrose College as a disc jockey at radio station KSTT in Davenport, Iowa. Pat McMahon currently works for radio station KTAR and television station AZTV in Phoenix, Arizona. (Courtesy KTAR Radio.)

Maggie Linton graduated from Leavenworth High School in 1966. Her first broadcasting job was with KANU-FM, where she was an anchor with the University of Kansas sports network and the traffic and continuity director. In 1974, she began working with KAKE-TV in Wichita as community affairs director and weekend sports anchor. She became the morning drive anchor for KSDK-AM in St. Louis in 1976. She has been the voice of *Sonic Theater* on XM-163 and hosts the *Maggie Linton Show* on XM Satellite Radio. (Photograph by Stacey Young, courtesy Maggie Linton.)

John Leavitt's career has included more than three decades as a practicing church musician and 20 years as a university music professor and director of choral activities. He has served as director for community choirs for children and adults and has published sacred and secular music for more than 30 years. He is a doctoral conducting graduate from the University of Missouri–Kansas City Conservatory of Music, which honored him in 2012 as Alumni of the Year. His music is performed regularly in more than 30 countries. (Courtesy Dr. John Leavitt.)

Neil Dougherty (April 14, 1961–July 5, 2011) is among the top 100 athletes at Leavenworth High School. The standout basketball player played two seasons under Mike Krzyzewski at West Point. His final two collegiate seasons were at Cameron University. After receiving his master's from Oklahoma in 1987, Dougherty served as an assistant at Cameron (1984–1988), Drake (1988–1989), and Vanderbilt (1989–1993). He unexpectedly died jogging while in Indianapolis working with a youth basketball program. (Courtesy Texas Christian University.)

Outstanding basketball player Wayne Simien (born March 9, 1983) lettered all four years at Leavenworth High School, leading his team to its first state championship his junior year in 2000. This McDonalds All American played for the University of Kansas under Roy Williams and Bill Self. He collected All-American honors his junior and senior years and was Wooden Award finalist both years. This Big 12 Player of the Year played in four NCAA tournaments, with two Final Four appearances, one National Runner Up finish, and one Elite Eight finish. Simien was the first-round pick (29th overall) of the Miami Heat, with whom he won an NBA championship in 2006. (Author's collection.)

Nine
Yesterday, Today, Tomorrow

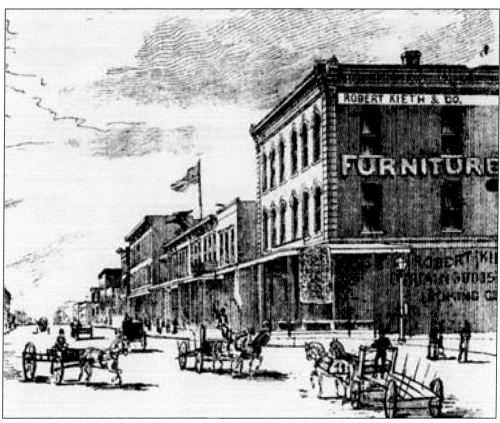

The history of Leavenworth from the very beginning has been second to none. Its importance to the development of the West has been well reported by publications of the time and historians throughout the past 163 years. This chapter pays tribute to that pioneering spirit. This etching, made from photographs taken by G.C. Whitaker depicting the south side of Delaware Street looking east from Third Street, appeared in the January 6, 1880, *Daily Graphic*, an illustrated New York evening newspaper. (Author's collection.)

H. Miles Moore was born in Brockport, New York, on September 2, 1826. Raised by his grandfather after the death of his parents, Moore was admitted to the New York Bar in 1848. From 1848 to 1850, he practiced law in Louisiana and ran a plantation. In 1850, he moved to Weston, Missouri, and practiced law. In 1854, after the signing of the Kansas-Nebraska Act, he moved to Leavenworth. He served as a delegate to the Topeka Constitutional Convention and the territorial legislature. Prior to his death in 1909, Moore wrote *Early History of Leavenworth City and County*, published in 1906. (Author's collection.)

This late 1800s view of Fourth Street looking north from Cherokee Street shows the National Hotel (left) and the National Café (right). During Leavenworth's earliest history, as many as 28 hotels have operated inside the city limits. This location today would show the Country Club Bank parking lot on the left and the Knights of Columbus Hall parking lot on the right. (Author's collection.)

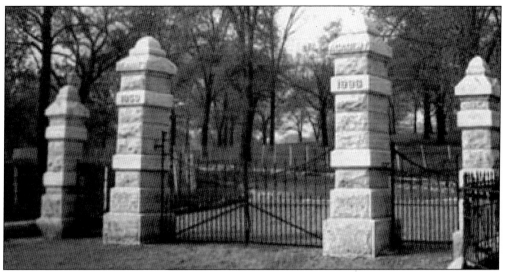

The Sisters of Charity came to Leavenworth in 1858 and began schooling boys and girls shortly thereafter. During the early years, they visited with wagon trains, tended to the sick during epidemics, took in orphans, visited prisoners, and taught black children fleeing to the Free State of Kansas. In 1859, they established St. Mary Institute in downtown Leavenworth. In 1870, they moved to their current location south of the city and renamed their school St. Mary Academy. In 1923, their name changed to St. Mary College, and they began accepting men in certain areas of study by 1932. The school continued to expand and became the University of St. Mary in July 2003. (Author's collection.)

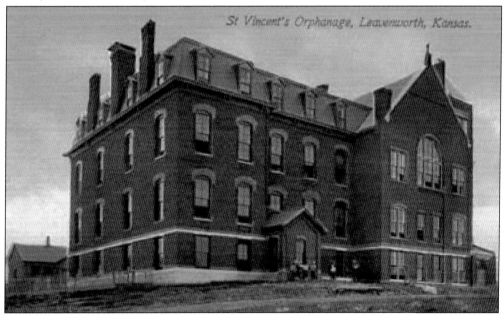

The Sisters of Charity opened the doors of St. Vincent's Orphanage in 1866. Located just north of the current St. John's Hospital, this building was torn down in March 1966 to make room for the Leavenworth Plaza Shopping Center. Several other orphanages operated in the city including the Protestant Orphan Asylum and Home for Friendless Children, the Guardian Angels Home for Boys, Holy Epiphany Home for Girls, and the Kansas Orphan Asylum. (Author's collection.)

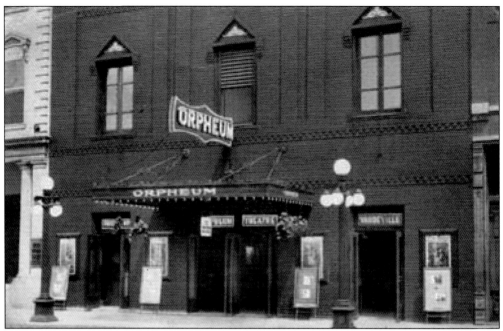

Long before multiplex cinemas and Imax theaters, there were places such as the Orpheum Theater at 326–328 Delaware Street. Like many theaters of the day, the Orpheum featured the best in silent films with music played by a live orchestra. (Author's collection.)

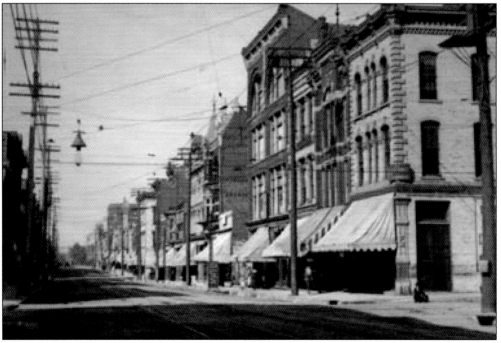

One of the earliest views of the corner of Fifth and Delaware Streets, this photograph was taken looking east in the mid-1890s. On the corner is the original Mehl & Schott's Pharmacy building. (Courtesy Leavenworth Public Library.)

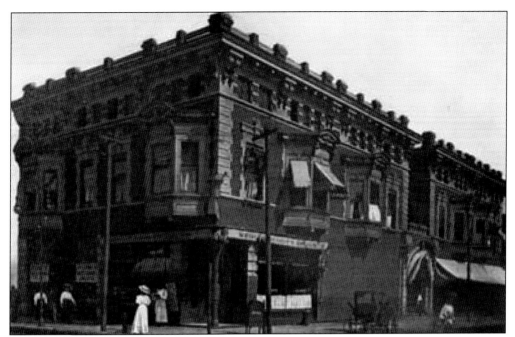

This view, taken less than 10 years later, shows the AXA Building, designed by William Pratt Feth. First known as the Epenscheid after original owner Charles Epenscheid, the building is two stories with room for six storefronts and several offices upstairs. The main building has been home to Mehl & Schott's Pharmacy, Clyde's Pharmacy, and the Corner Pharmacy. (Author's collection.).

The AXA Building was purchased by pharmacist Ron Booth in 1980 and meticulously restored to its original grandeur. The soda fountain was moved and expanded and includes a 40-foot mahogany bar and lunch counter featuring all the attributes of a 1960s lunch counter. For years, the fountain was the town's lunch-time hot spot. When the owner and his staff announced their retirement and the closing of the Corner Pharmacy and Fountain, many were saddened. On the last day of operation, March 19, 2015, the business was filled to capacity. Many smiles, hugs, and tears filled the air. Since 1871, a pharmacy had operated a total of 144 years on this corner. (Author's collection.)

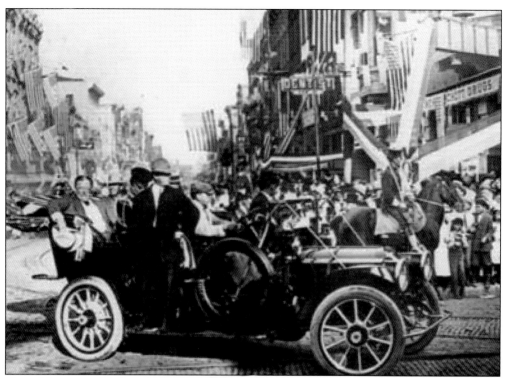

One of the most published photographs in Leavenworth history is this September 29, 1911, picture of Pres. William Howard Taft rounding the corner at Fifth and Delaware Streets in front of Mehl & Schott's Pharmacy. Seated to the right of President Taft in the hat is US representative and Leavenworth native Daniel Read Anthony Jr. (Author's collection.)

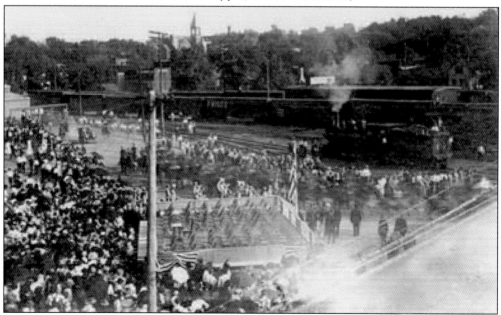

The president's motorcade was rounding the corner headed for Haymarket Square, where he was to deliver a speech to 20,000 people defending his tariff policy. (Author's collection.)

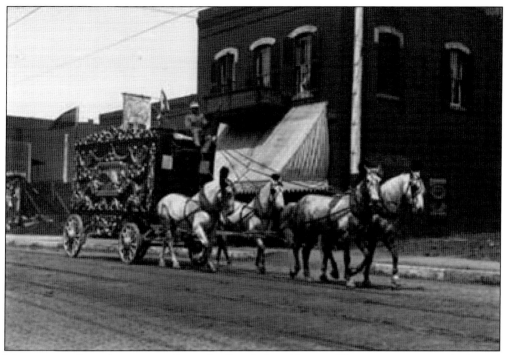
Many towns along the transcontinental railroad played host to Chautauquas, tent revivals, and the circus. This photograph, taken by Frank Morrow, shows a circus that appeared around 1909. (Courtesy Kenneth Spenser Research Library, University of Kansas Libraries.)

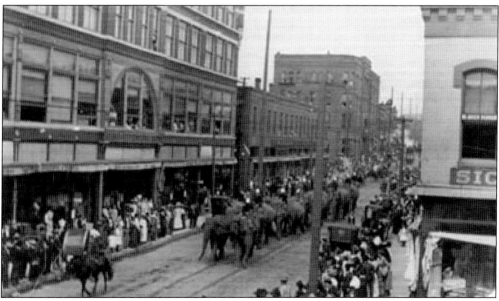
On July 22, 1904, the Ringling Bros. Circus made its only appearance in Leavenworth. Other carnivals and circus groups have performed here throughout the town's history. Here, pachyderms parade past the Ettenson Building, ready to turn the corner onto Cherokee Street and head toward Haymarket Square. (Author's collection.)

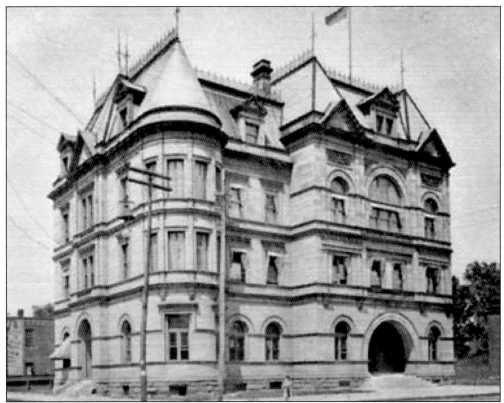

The first Leavenworth Post Office was established on March 6, 1855, and the post office pictured here opened on May 31, 1871 on the northeast corner of Shawnee and Fourth Streets. This building also contained the offices of the federal courts and other government agencies and served the community until the late 1950s. (Author's collection.)

During the construction of the new post office building, the post office was located across the street in the Cody Hotel. A detail of US Marshals were assigned to act as security for the hotel until completion of the new building, which opened in 1961. (Author's collection.)

The Leavenworth County Fairgrounds, according to early city maps, were located in the area of Metropolitan Avenue between Eleventh and Sixteenth Streets. The grounds included a racetrack with grandstands, exhibit buildings, and an open-air tent complete with boxing ring. (Author's collection.)

In the late 1890s, the fairgrounds relocated to Shrine Park Road south of Limit Street. This area also included a racetrack and exhibition buildings and provided a man-made lake for swimming, rowing, and camping. (Courtesy Kenneth Spencer Research Library, University of Kansas Libraries.)

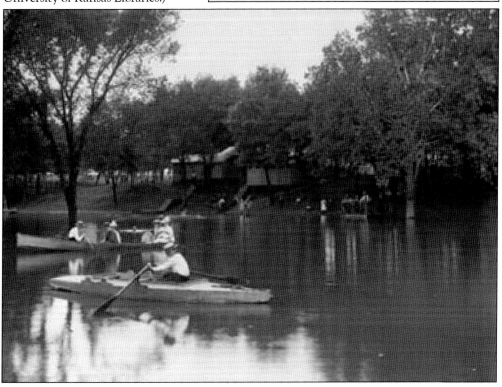

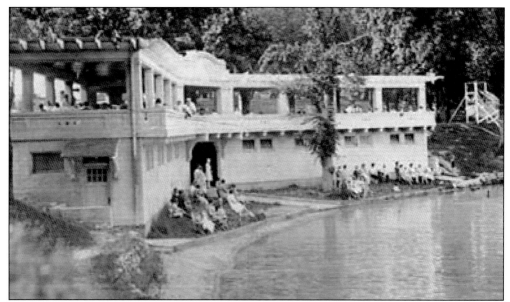

The pavilion at Shrine Park provided a bathhouse for swimming and boating below and a balcony for formal events, dances, and family gatherings above. (Author's collection.)

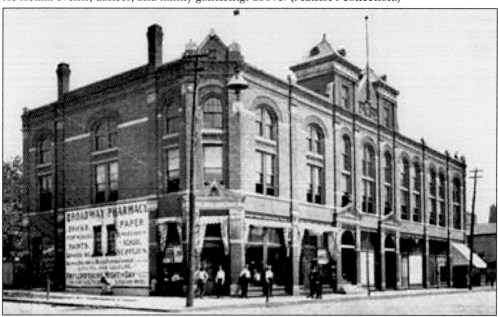

The original Turner Hall was erected in 1857 on the northwest corner of Sixth and Delaware Streets. The popular meeting place, where plays, music, and comedy were presented, stood for 30 years. During the election of 1862, it was a polling site. A group of Redlegs were stationed outside the building, preventing people from voting. H. Miles Moore was riding by and saw a friend being tossed about by the ruffians. The friend told Moore that he was trying to vote and the Redlegs would not let him. Moore dismounted, pulled his revolvers, and pointed them at the crowd. Afterwards there were no issues with people voting. In 1887, a second Turner Hall opened at the corner of Broadway and Shawnee Street. It was torn down and replaced by the Russell Pharmacy Building. (Author's collection.)

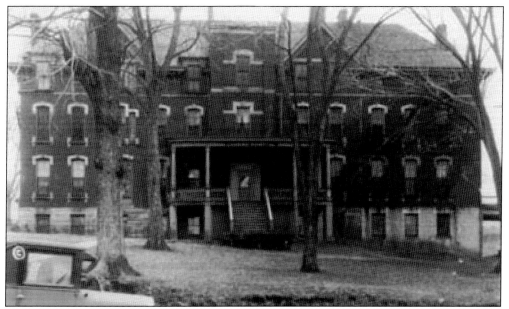

Cushing Hospital was chartered on January 14, 1870, by the Kansas Association for Friendless Women and named after the founder, Harriett Cushing. The original charter stated that the purpose of the hospital was to "afford protection, employment, or assistance to women, to shelter them from temptation and to encourage them to a life of virtue." (Author's collection.)

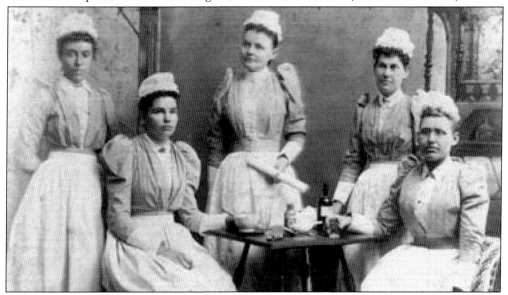

The Cushing Hospital, Home for the Friendless, and Training School for Nurses offered a four-year course of study. Nurses performed their duties under strict rules. Rule number one was: "Nurses must rise when the rising bell rings at 6 a.m. Before leaving the dormitory to go on duty in the hospital each nurse will sweep, dust, make her bed, see that her room is properly aired, the washstand left in order, and the towels are folded and hung on the rack. Attention must be given to closets and drawers. Nurses are strictly forbidden to scratch matches, or drive nails into the wall or deface the walls in any way. Nurses' rooms are open for inspection by visitors at any time during the day." (Author's collection.)

The Wulfenkuhler State Bank was established in 1867 with Otto Wulfenkuhler as president. The bank vault included Union safety deposit boxes, a major advertising point. At 7:30 p.m. on February 19, 1936, a fire alarm was triggered, and when firefighters arrived, the building was totally engulfed. With nearly 3,000 onlookers, firefighters fought the fire as well as the subzero conditions. Three firefighters suffered minor injuries. Nearly 60 offices in this building housed the majority of the town's doctors, lawyers, and dentists. (Author's collection.)

The Hollywood Theater opened on July 23, 1938. Two thousand patrons were entertained by a Paramount newsreel, a feature by *Popular Science*, a Silly Symphony cartoon, a sports story, and *Little Miss Broadway*, staring Shirley Temple. The northwest corner of Fifth and Delaware Streets has been home to the First Congregational Church, Wulfenkuhler Bank, and the Hollywood Theater. Today, the theater is home to the River City Players, a local theater group. The Landing Four Movie Theater is a state-of-the-art facility in the downtown business district. (Author's collection.)

In 1913, John and Theresia Seber opened what would become one of the town's biggest businesses, Seber Hatchery. What began as a small venture by John Sr. with one incubator that he designed grew into one of the largest poultry operations in the Midwest. This photograph shows the company truck, a 1938 Chevy, at Haymarket Square across from the family-owned Seber Feed and Flour Store at Seventh and Cherokee Streets. (Courtesy Kathy Seber.)

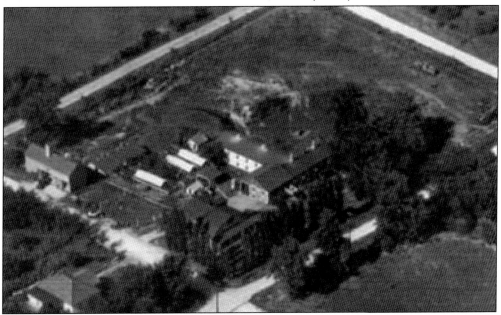

The hatchery at Marion and Spring Garden Streets is seen in the 1940s. In one year, the hatchery produced approximately 368,000 fryers and broilers as well as baby chicks. So successful was the business that a 1952 article in the *Topeka Daily Capital* labeled John Sr. the "broiler king." In 1948, the family added a separate laying house called "chicken city." The three-story building resembled an apartment complex. (Courtesy Kathy Seber.)

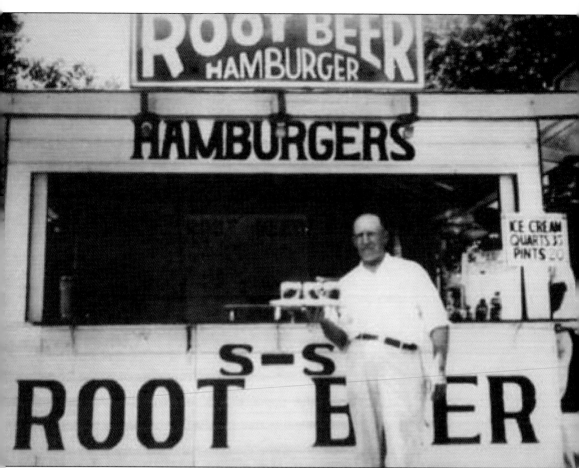

Homer McKelvey opened his first root beer stand just off the alley between Vine and Elm Streets on the west side of Fourth Street in 1931. As his business grew and his menu expanded, he moved two more times, and it has been at the current location since 1938. Serving hot food and memories, this drive-through diner has served generations of locals as well as visitors for 86 years. (Author's collection.)

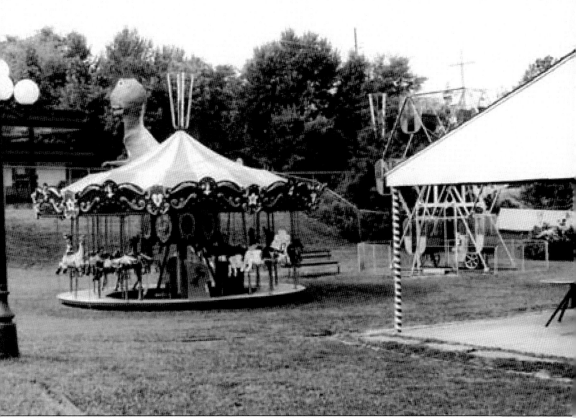

In the spring of 1951, one of the town's most beloved landmarks opened on the corner of Spruce Street and Lawrence Avenue. Carl and Ruth Theel started Kiddieland with three ponies, a trackless train ride, a little car ride, and four planes. Soon afterwards, the small amusement park grew to include a boat ride, Ferris wheel, handcar, and merry-go-round. For a short time, the park even had a miniature golf course. Theel Manufacturing Company made amusement rides that were sold all over the country. Kiddieland officially closed after the 1997 season, having provided 47 years of smiles and countless hours of fun for thousands of kids and adults. Following the passing of Carl Theel in 1992, his wife, Ruth, reminisced, "We loved it, those little children came down there thrilled to death, clapping their hands and jumping up and down. That did it. That made it worth it." (Courtesy C.W. Parker Carousel Museum.)

"If you can't find it anywhere else Gronis Hardware will have it." This popular statement can be heard from locals all over town when a difficult item just cannot be found. Delmar Poell and his wife, Josephine Gronis, purchased the hardware store from Josephine's brother John Gronis, who had originally purchased the operation in October 1940 from Oliver Ousler. Since 2000, the operation has continued to be a family-owned hardware store run by Joan Gronis Poell Hall and her children, Beth and Mike. This is the only store in town that still operates and is stocked as it was in the early days. (Author's collection.)

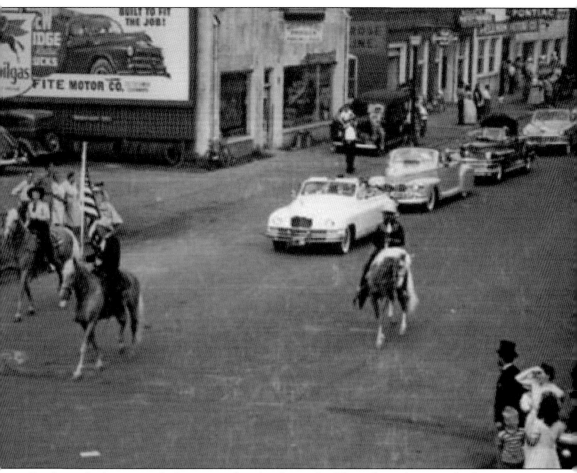

For those who love a parade, Leavenworth is the place to be. Throughout the years, the downtown streets have hosted the Apple Parade, centennial parades, Buffalo Bill Days celebrations, and Shriners parades. Easter, St. Patrick's Day, and Christmas parades are among the annual events. (Courtesy Leavenworth Public Library.)

Leavenworth is home to the largest Veterans Day parade in the United States. The annual salute to America's veterans is attended by thousands. At precisely 11:00 a.m., the parade comes to a halt and the crowd falls silent as it honors those who have given their all in the service of their country, followed by a prayer, a fly-over, and the playing of "Taps." (Author's collection.)

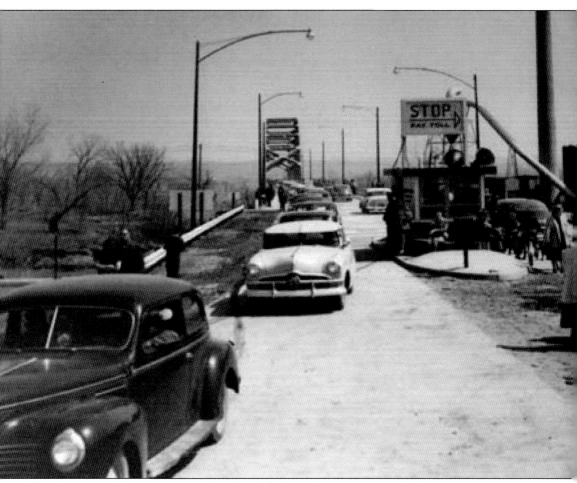

The Centennial Bridge was completed and dedicated on April 2, 1955. Leavenworth mayor Ted Sexton and the city council decided on the name to honor those who gave their lives in defense of their country from 1854 to 1954. A *Times* article reported that within the first six hours, 3,600 cars had driven across the bridge. Local businesses donated various prizes, and every 25th car to cross the bridge was a lucky winner. Since its earliest days, Leavenworth has bridged many gaps in America's history. It opened the doors to Western expansion, local trade, and commerce worldwide. As time continues, new bridges are crossed. A new manufacturing complex has been built, and plans for a new technological park complex and a new bridge are in the works. New storefronts operate in renovated buildings that have stood the test of time. It is home to the military and civilian population of Fort Leavenworth as well as state and federal prison facilities. It is much more than a military town, or a prison town, it is hometown USA, where the pioneering spirit of its forefathers continues to push the pioneering spirit of today and tomorrow. (Author's collection.)

Discover Thousands of Local History Books
Featuring Millions of Vintage Images

Arcadia Publishing, the leading local history publisher in the United States, is committed to making history accessible and meaningful through publishing books that celebrate and preserve the heritage of America's people and places.

Find more books like this at
www.arcadiapublishing.com

Search for your hometown history, your old stomping grounds, and even your favorite sports team.

Consistent with our mission to preserve history on a local level, this book was printed in South Carolina on American-made paper and manufactured entirely in the United States. Products carrying the accredited Forest Stewardship Council (FSC) label are printed on 100 percent FSC-certified paper.